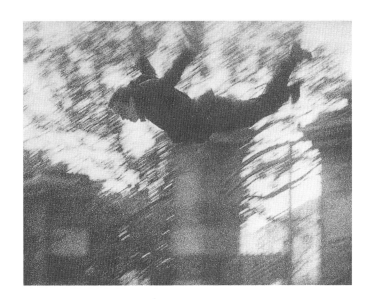

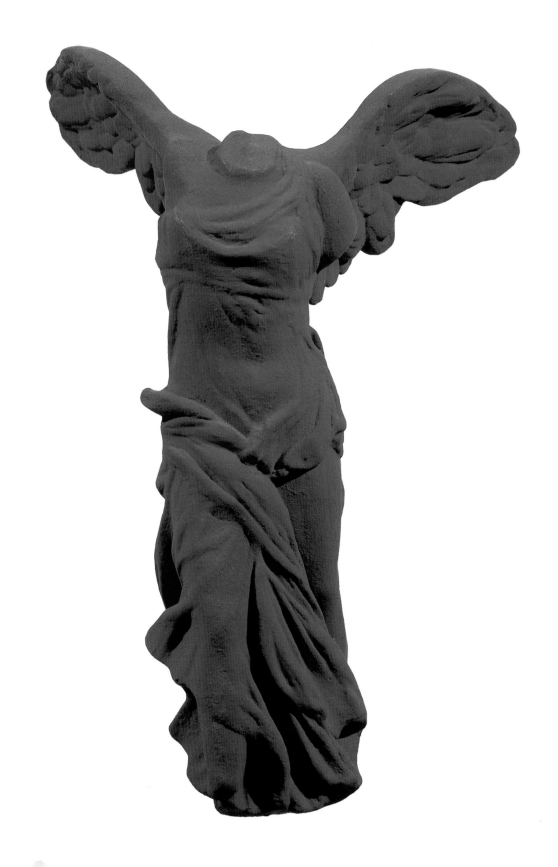

Hannah Weitemeier

YVES KLEIN

1928–1962

International Klein Blue

TASCHEN

KÖLN LONDON MADRID NEW YORK PARIS TOKYO

© 2001 Taschen GmbH
Hohenzollernring 53, D–50672 Köln
www.taschen.com
© 1994 for the illustrations of Yves Klein: Daniel Moquay, Paradise Valley, AZ
© 1994 for the illustrations of Jean Tinguely, Robert Rauschenberg, Henri Matisse,
Jacques de la Villeglé, Mark Rothko: VG Bild-Kunst, Bonn
Editing and design: Simone Philippi, Cologne
English translation: John William Gabriel, Worpswede
Cover design: Catinka Keul, Angelika Taschen, Cologne

Printed in Germany
ISBN 3-8228-5643-6

Contents

Yves – le Monochrome

"A new world calls for a new man" – that was the message with which Yves Klein, in the mid 1950s, took the international art world by storm. The young artist's extravagant personality and unique style had captivated Paris from his first appearance on the scene. The blue paintings – large-format canvases, sheer, meditation-inspiring surfaces suffused with the deepest hue of the sky – rapidly made him famous as "Yves – le Monochrome" far beyond the borders of France. Yet they were only the beginning of a universal quest. Perhaps sensing that his life was destined to be short – he died in 1962, at the age of 34 – Klein created over a thousand paintings in the course of only seven years. His œuvre has since been recognized as a classical achievement of modern art, firmly rooted in the Western artistic tradition and yet a source of still unexhausted innovative potential.

Clearly distinguishing between talent and genius, Klein sought something in his life "that was never born and never died," an absolute value, the Archimedean point from which the circumscribed, material world could be levered out of its immobility. The logical conclusion was to choose a point outside the limits of mundane, familiar events, and Klein set out to develop a method to find it.

"A painter ought to paint one single masterpiece: himself, perpetually ... becoming a kind of generator with a continual emanation that fills the atmosphere with his whole artistic presence and remains in the air after he has gone. This is painting, the true painting of the twentieth century," Klein wrote on 7 September 1957, in his diary, posthumously published as *Mon Livre*.

Klein never learned the trade of painting; he was born to it, having, as he said, "absorbed the taste of painting with my mother's milk." His father, Fred Klein, was a landscape artist of the southern French school, and his mother, Marie Raymond, belonged to the vanguard of *l'art informel* in Paris.

Yves was born in the house of his grandparents in Nice, on 28 April 1928. His boyhood was marked, on the one hand, by the atmosphere of freedom that prevailed in the continually changing circle of his parents, who from 1930 to 1939 lived mostly in Paris, but spent their summers among artist friends at Cagnes-sur-Mer. On the other hand, from the time of his birth Yves also experienced the constant loving care of his aunt, Rose Raymond, who lived in Nice and whose outlook on life, more realistic than that of her sister, led her to make the boy's everyday concerns her own. His formative years on the sunny Mediterranean were thus subject to two opposing influences: that of the *idées forcées* of the free artistic spirit Yves so admired in his parents, and that of the *élan vital* of his Aunt Rose, earthy and more oriented towards material success. In addition, the conflict his parents went through in deciding between figurative and abstract art instilled a sense of resistance in the young Yves which eventually was to lead him beyond the avant-garde issue entirely. The decision to employ color in pure form as an expression of a free-floating sensibility came at a

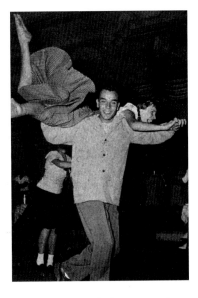

Nice, 1946: Caught up in the postwar euphoria that came with a fresh start, Klein played jazz piano, dreamed of becoming a bandleader, and danced the bebop with flair.

PAGE 6:
M 26, 1949

very early point in his career, prompting Klein to reject line and restricting contour as an imprisonment in formal and psychological concerns, and to rely solely on the perceptions of the spirit.

Klein's first attempts to achieve the impossible were undertaken together with two friends, Armand Fernandez – who, as Arman, was to gain a reputation as the inventor of the accumulation – and the young poet Claude Pascal. The three friends met clandestinely at Arman's house, in a basement room painted blue. In a latter-day search for the philosopher's stone, they immersed themselves in esoteric literature and alchemy. They meditated on the roof of the house, and fasted one day in the week, one week every month, and one month every year – at least that was the plan. They played jazz and danced to bebop (p. 7), learned judo, and conceived of riding around the world on horseback, destination Japan. Their playful megalomania did not even stop short at the notion of dividing up the universe among themselves. Arman claimed "le plein", the riches of the earth, the abundance of material things; Claude, fledgling poet, appropriated words; and Yves characteristically chose the etherial space surrounding the planet, "le vide", the void, empty of all matter.

The boundlessness of the heavens had long been a source of inspiration to Klein. At the age of nineteen, as he lay on the beach one hot, sunny summer day in the south of France, he embarked on a "realistic-imaginary" mental journey into the blue depths. On his return he declared, "I have written my name on the far side of the sky!" With this famous symbolic gesture of signing the sky, Klein had foreseen, as in a reverie, the thrust of his art from that time onwards – a quest to reach the far side of the infinite.

The event marked the beginning of Klein's painting career, a "monochrome adventure" that began in earnest in Ireland. He and Claude Pascal went there hoping to take riding lessons, but their money ran out, Claude fell ill, and Yves was left, alone and destitute, in London. He managed to find a job as assistant to Robert Savage, a gilder and friend of his father's, who in 1949 and 1950 taught him the basics of painting, the craft of preparing grounds, rubbing pigments, and mixing varnishes. Two years later, when he finally boarded ship in 1952 for his long-awaited trip to Japan, Klein proclaimed to gathered friends that he intended to make "monochromy" the fundamental concept of his art.

The actual purpose of his stay in Japan in 1952 and 1953 was to undergo the physical and mental rigors of training in judo at the renowned Kôdôkan Institute in Tokyo. Klein's art – especially its unprecedented focus on the metaphysical – cannot be fully understood without reference to judo as a source of self-discipline, intuitive communication and a mastery of the body. Judo also helped him develop his powers of concentration and cooperation with others, and Klein achieved a Black Belt and 4th Dan grade. Through the techniques of judo, he not only learned to fight with agility, but to win with a minimal expense of effort.

After a brief stay in Madrid, Klein returned to Paris in late 1954, where his theories of monochrome painting initially found little hearing. The first Paris show of his work at the Club des Solitaires, held in 1955 under the aegis of Editions Lacoste, went almost completely unnoticed. That same year he submitted a monochrome canvas, *Expression de l'Univers de la Couleur Mine Orange*, to the Salon des Réalités Nouvelles at the Palais des Beaux-Arts de la Ville de Paris. The selection committee rejected the work, advising Klein that the addition of a second color, a point, or a line might improve it.

Still, he remained undaunted in his belief that pure color indeed represented "something" in itself. Searching for a congenial interpreter, Klein came across Pierre Restany, an art critic who spontaneously understood him, seemingly without the need for explanation. The contact with Restany was to confirm Klein's idea of "direct communication," and marked a turning-point in the acceptance and understanding of his art the effects of which continue to be felt today.

M 6, 1956

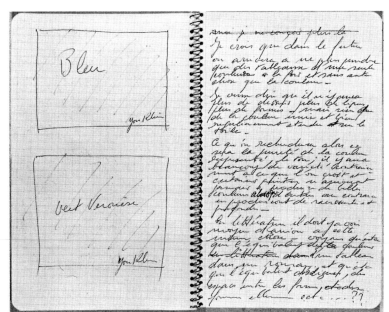

Journal entry for 27 December 1954.
Klein's first experiments in monochrome
painting were made in diary entries dating
from as early as 1947–48. Here, he writes,
"I believe that in future, people will start paint-
ing pictures in one single color, and nothing
else but color…"

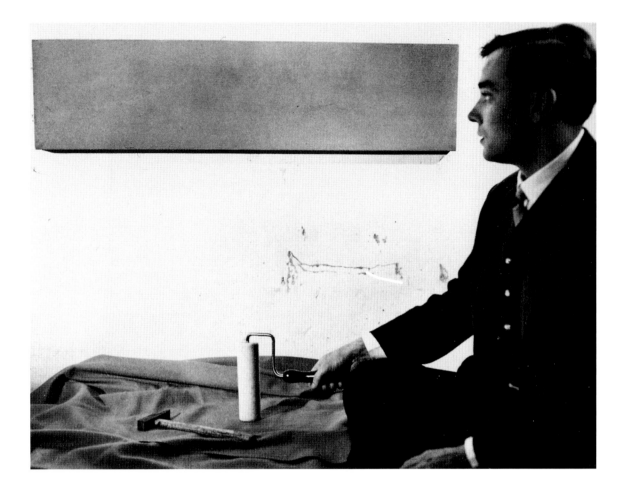

It all began on 21 February 1956, the opening day of Klein's second Paris show, held at the Galerie Colette Allendy, a key venue of the avant-garde. With the exhibition title, "Yves: Propositions monochromes", and his catalogue introduction, "La Minute de Vérité" (The Minute of Truth), Restany set out to explain the theoretical bases of the artist's new approach. After Restany's discussion with Louis-Paul Favre was published in the daily *Combat*, the issue of an aesthetic involvement with a single color finally began to attract serious interest on the Paris art scene.

Klein became known as "Yves – le Monochrome." Asked what this, and his art, were supposed to mean, the artist used to recount an ancient Persian tale: "There was once a flute player who, one day, began to play nothing but a single, sustained, uninterrupted note. After he had continued to do so for about twenty years, his wife suggested that other flute players were capable of producing not only a range of harmonious tones, but even entire melodies, and that this might make for more variety. But the monotonous flute player replied that it was no fault of his if he had already found the note which everybody else was still searching for."

By this time, Klein had already put the parable of the flute player into practice, and not only in his painting. He had composed a symphony based on a single, vibrating note and extended silence, a two-part continuum of sound and soundlessness which, as it were, formed the overture to his artistic career. The

Yves Klein in his studio, c. 1956

PAGE 10:
M 12, 1957
In his first attempt to publicly exhibit a monochrome painting in Paris, Klein submitted a large-format work in orange to the Salon des Réalités Nouvelles in 1955. It was turned down by the selection committee, who advised him to add at least a second color, a line, or a point. Still, Klein remained convinced that color represented "something" in itself.

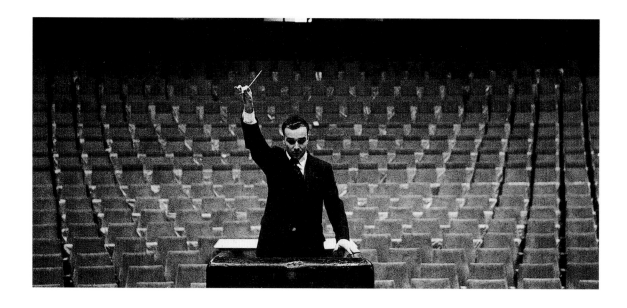

Yves Klein as conductor, Gelsenkirchen
Theater, 1958
The artist as conductor of his own spiritual
and intellectual existence, at his debut on the
world art scene with a single-note orchestral
sound and a single-color visual image.

Monotone Symphony – Silence (p. 12), performed repeatedly between 1947 and
1961, was to accompany the culminating points in his art and to prefigure the na-
ture of his life as an orchestration of multiple voices. In analogy to his sym-
phony, Klein's œuvre emerged from the primordial chaos like a bright comet,
diaphanous at first, then growing to dazzling brilliance, and finally fading to an
afterglow, leaving a reverberating silence in its wake.

To extend the musical analogy, Klein might well be characterized as the con-
ductor of his own spiritual existence, ready at every moment to give the cue. In
a photograph, *Yves Klein as conductor*, taken at the Gelsenkirchen Theater in
1958 (p. 12), he appears to defy the force of gravity, hovering before an invisible
audience in an empty auditorium. Raising his arm with an omniscient gesture,
he commands our attention for the aesthetic event he holds in store. For Yves
Klein always saw himself as "le peintre de l'avenir," the painter of a future an-
ticipated in the here and now.

Monotone Symphony – Silence, 1947–1961

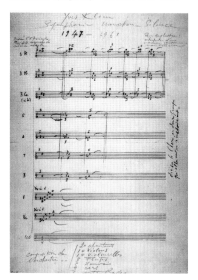

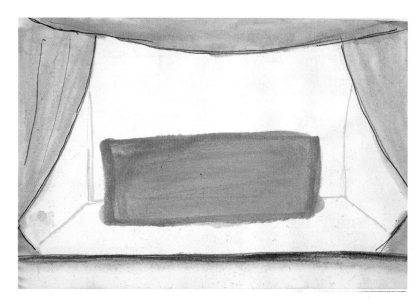

Sketch from the artist's journal, 1954
After making a few tentative essays in
figuration in Madrid, on his return to Paris
in 1954 Klein sketched his first mono-
chrome surface in red-orange – here still
in the dramatic setting of a proscenium
stage.

M 7, c. 1950

"The Blue Epoch"

With his Monochromes in a single, uncut color, Klein had established the visual effect of pure pigments. But a thorny problem remained: as soon as the dry pigment was mixed with a painting medium, its brilliancy diminished. Far from being merely a technical point, this phenomenon represented a conceptual challenge as well. Less important than achieving an aesthetic effect to Klein was the attempt to find a correspondence between color and human scale. To his way of thinking, every canvas was to possess an intensity that would draw the viewer into it, trigger his or her emotional sensibilities. For years, Klein searched for a paint formula that would help fulfil this demand.

In 1955 he found a practicable solution to the problem of color intensity, in a new chemical product marketed at that period under the name of "Rhodopas." This was a synthetic resin normally employed as a fixative. When it was thinned, Klein found, it could be used to bind pigments without materially altering their luminosity. The result was a matte, unreflecting paint that, saturating the canvas ground, produced a surface whose gently vibrant effect on the eye was akin to a double exposure, an effect Klein sometimes referred to as "a sensitized image," "poetic energy," or "pure energy." To the extent that such paintings appeared to take on a life of their own, Klein felt they represented adequate manifestations of a universal sense of space. "For me," he said at the opening of his 1955 exhibition at Editions Lacoste, "every nuance of a color is, in a sense, an individual, a living creature of the same species as the primary color, but with a character and personal soul of its own. There are many nuances – gentle, angry, violent, sublime, vulgar, peaceful." From the reactions of the audience, however, he realized that far from being able to see intentions of this nature in his work, viewers thought his various, uniformly colored canvases amounted to a new kind of bright, abstract interior decoration. Shocked at this misunderstanding, Klein knew a further and decisive step in the direction of monochrome art would have to be taken. His involvement with nuances and gradations would cease, and from that time onwards he would concentrate on one single, primary color alone: blue. This blue, eradicating the flat dividing line of the horizon, would evoke a unification of heaven and earth.

By the autumn of 1956, Klein had found what he was looking for, a saturated, brilliant, all-pervasive ultramarine he called "the most perfect expression of blue." The pigment was the result of a year of experiments, in which Klein was aided by Edouard Adam, a Paris retailer of chemicals and artists' materials. To bind the pigment and adhere it to the support, the two developed a thin solution consisting of ether and petroleum extracts. With this blue, Klein at last felt able to lend artistic expression to his personal sense of life, as an autonomous realm whose twin poles were infinite distance and immediate presence. In analogy to the overtones in music, the specific hue of the pigment engendered a visual sensation of complete immersion in the color, without compelling the viewer to define its character.

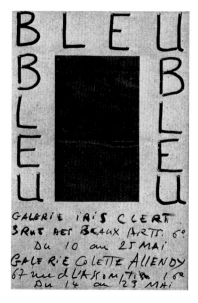

Poster for Klein's dual exhibition at Galerie Iris Clert and Galerie Colette Allendy, Paris, 1957

PAGE 14:
IKB 3, 1960
"To sense the soul, without explanation, without words, and to depict this sensation – this, I believe, is what led me to monochrome painting."
Yves Klein

Blue Reliefs: S 1, S 3, S 4, S 5, 1957

Blue, the color of the sea and sky, evokes distance, longing, infinity. "This color has a strange and almost unutterable effect upon the eye. It is, in itself, an energy... There is something contradictory in its aspect, both stimulating and calming. Just as we perceive the depths of the sky and distant mountains as blue, a blue surface appears to recede from the eye. Just as we wish to pursue a pleasant object that moves away from us, we enjoy gazing upon blue – not because it forces itself upon us, but because it draws us after it."
Goethe, *Theory of Color*, 1810

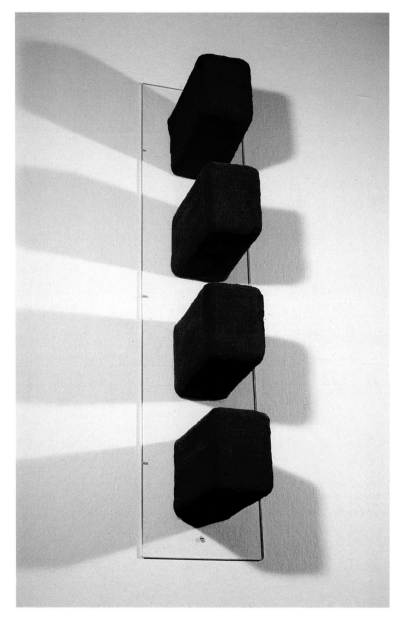

In 1957 Klein proclaimed the advent of the "Blue Epoch", sending out invitations to his dual Paris exhibition with an original *Blue Stamp*. His apotheosis of blue soon earned him an international reputation, as "Yves – le Monochrome."

IKB 45, 1960

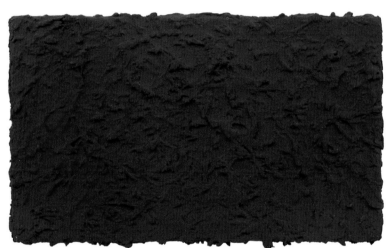

Klein's patent on *International Klein Blue* (IKB), 1960
With patent no. 63471, dated 19 May 1960, the French Patent Office officially declared the chemical composition of Klein's IKB pigment a protected invention.

The pure blue pigment, applied without modulation and without a trace of personal touch – apart from the barely visible wavy texture produced by the roller – raised the factor of color in art to an absolute level. It was also significant that at this point Klein began to concentrate on upright formats, with slightly rounded corners and an extension of the painted surface around the stretcher edges that further distinguished these works from traditional panel paintings with their clearly defined boundaries. In addition, the artist deliberately mounted the canvases not on the wall, but up to twenty centimeters in front of it. Seemingly detached from the architectural stability of the room, the images created an impression of weightlessness and spatial indeterminacy. The viewer felt drawn into the depths of a blue that appeared to transmute the material substance of the painting support into an incorporeal quality, tranquil, serene. The emotion invested in the creation of such imagery was matched by the freedom of the viewer to see and feel whatever he was prompted to in its presence. Nowhere could the eye find a fixed point or center of interest; the distinction between the beholder, or subject of vision, and its object began to blur. This, Klein believed, would lead to a state of heightened sensibility.

The Blue Monochromes have since come to be considered the quintessence of monochrome painting in the twentieth century. In the eyes of Thomas McEvilley, an art historian who has been investigating the dualism of art and life in Klein's work since the 1970s, his art represents nothing less than an embodiment of the contradictions of modernism, and hence of the principles our century and culture persist in seeing as dialectically opposed: mind and matter, the metaphysical and the physical, infinity and time.

In retrospect, it is important to remember that in the 1950s Klein's hypotheses still seemed extremely shocking, especially in the intellectual climate of an art center deeply and jealously involved in the debate over *l'art informel*. Klein's recourse to the metaphysical fit into none of the categories then prevailing on the Paris scene. What the cultural élite there found particularly outrageous was the fact that his visionary ideas not only attracted international critical attention from the start, but were avidly publicized by the media. Even at that early point, Klein had arrived at the conclusion that there were no objective limitations on artistic expression, neither as regards content nor form. The only authority he recognized was that of his own, inward voice. So crucial was this to him that he even went to the lengths of taking out a patent on the color he had invented, *IKB*, or *International Klein Blue* (p. 17). Contrary to popular belief, the registered trademark was not intended merely to protect his original contribution to the metaphysical in art. As he had foreseen as early as 1960, it was the only way to ensure that what he called the "authenticity of the pure idea" would remain uncorrupted in future times. The patent was a wise decision, for soon Klein's blue would be a byword around the globe.

"You don't become a painter, you just discover one day that you are one," Klein once summed up his career. Back in the 1950s, only a very small circle of friends and artists were aware of the logic and concentration with which he pursued his goal. Klein's sense of responsibility was so strong that he staked his entire life on his art, knowing full well that he might fail, but borne up by an unshakeable enthusiasm and a belief in the unique beauty of the creative manifestations of the human mind. "Art... is not some inspiration that comes from who knows where, takes a random course, and presents nothing but the picturesque exterior of things. Art is logic *per se*, adorned by genius, but following the path of necessity, and informed by the highest laws," noted Klein in his journal. In this statement are contained the polarities of tension between which his art was to develop – the past of the classical painting tradition, and the future of an art in the process of emergence.

The year 1957 marked the turning point in Klein's career. Contrary to expectations, his first "Proposte monochrome, epoca blu" (Proclamation of the Blue

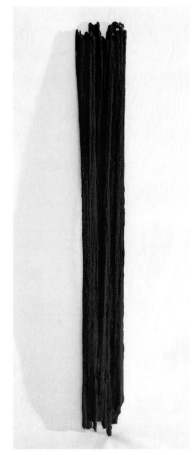

S 31, Blue Sculpture, c. 1957

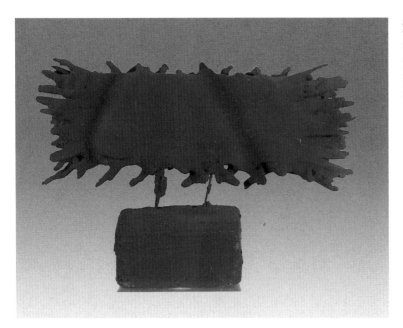

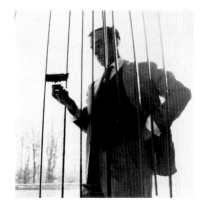

Epoch), staged at Galleria Apollinaire in Milan, proved resoundingly successful. At short notice, Klein had decided to execute eleven paintings for the show, all in monochrome blue, and all identical in format and technique, but each with a different price-tag. This was a risky undertaking, because it was the first time he had filled a space with works in a single color, and in a gallery outside France at that. But the many viewers, and especially buyers, proved him right. For an individual and unique experience of a picture that was basically identical to the other ten, they were indeed willing to pay a unique price. The Italian sculptor and painter Lucio Fontana spontaneously purchased one of the blue images, and his encounter with Klein developed into a lifelong friendship. Another Italian artist, Piero Manzoni, was lastingly influenced by the exhibition. These were only two of the many artists and collectors whose outlook on art was profoundly changed by a confrontation with Klein's vibrant blue color fields.

The "Blue Epoch" went on to be shown in Paris, Düsseldorf, and London, eliciting reactions that ranged from indignant scorn to a mystification of the artist as a hero for our times. The Paris exhibition took place at two venues concurrently, and was advertised on a joint poster (p. 15). The invitations themselves were miniature works of art, bearing a printed text by Pierre Restany and a *Blue Stamp* by Klein (p. 17). The dual show commenced at Iris Clert's avant-garde gallery, recently opened on Rue des Beaux-Arts. Titled "Yves – le Monochrome", it comprised a selection of the already classic blue monochrome canvases, accompanied by a performance by Pierre Henry of the *Monotone Symphony* in its original version. On the evening of the vernissage, one thousand and one blue balloons were released from Saint-Germain-des-Prés in the heart of Paris, and floated, as Klein's first *Aerostatic Sculpture*, into the blue night sky. The event, still innovative in a pre-happening world, represented a symbolic ascent of the artist's ideas from earth to heaven.

Four days later, at Colette Allendy's prestigious villa, he presented a show that brought his ideas very much back down to earth. "Pigment pur" was devoted to the things that had inspired Klein, in nature, the arts, and the cosmos, transformed into the memory images of *Blue Sculptures*. On view were such milestones of his art as the mundane objects suffused with blue, from the dinner-

Klein with *S 14, Blue Trap for Lines*, 1957

PAGE 21:
IKB 160 c, Blue Wave, 1957

IKB 190, 1959

PAGE 23:
IKB 2, 1961

Yves Klein and Rotraut Uecker met in summer 1957 at Arman's studio in Nice. It was the beginning of a profound love and an intense artistic collaboration.

S 12, Blue Venus, undated

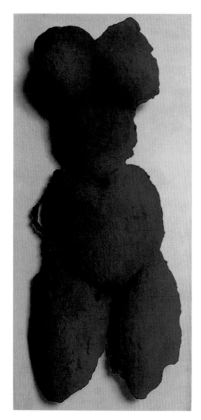

plate *IKB 54* (1957; p. 18) to the serrated length of wood titled *S 31* (c. 1957; p. 19). Taken from their familiar context and reworked, the found objects were raised to the status of art. Yet unlike the American Pop artists, who in the 1960s would react similarly to man-made consumer products, Klein treated his finds in a way that placed his work in a typically European context of meaning. Whether prefabricated or natural in origin, each object was conceived and reworked in an attempt to lend it a dynamic harmony that would stimulate individual perception, and a recognition that things habitually considered part of the external world possessed the same fundamental structure and laws as those which govern the individual organism. In one form or another, each piece contained covert allusions to a reciprocal influence between the subjective and objective references of a self-contained artistic universe.

Included in the Colette Allendy show were paint rollers Klein had used to make his works, mounted on a metal frame; a five-section folding blue screen; a blue carpet; natural sponges soaked in blue; and an evocation of blue rain (p. 20) in the form of twelve slender dowels, about two meters in length, dangling in a row next to the related object *Blue Trap for Lines* (p. 20). Then came a blue-painted globe, and, scattered on the floor, blue pigment that was to be carried around the gallery by the visitors' movements. Later, Klein was to augment this blue universe by a few, significant works of art from Paris museums, such as small-scale plaster replicas of *The Victory of Samothrace* (p. 2) and one of Michelangelo's Slaves, both of them paradigms of Western culture, and both holding a position of prominence in the Louvre.

In sum, the 1957 exhibition with Colette Allendy already embodied a confrontation between past and future in Klein's œuvre. Some people at the vernissage might have suspected this when they went into the garden, where the artist had set up a blue panel to which sixteen flares were attached, in four rows of four. Before their astonished eyes, Klein ignited the flares, and the picture went up in a brief but spectacular blaze. This ephemeral monochrome, titled *Bengal Flares M 41 – One-Minute Fire Painting* (pp. 28 and 29), has since attracted much and varied interpretation on the part of art historians. But it was not the only sur-

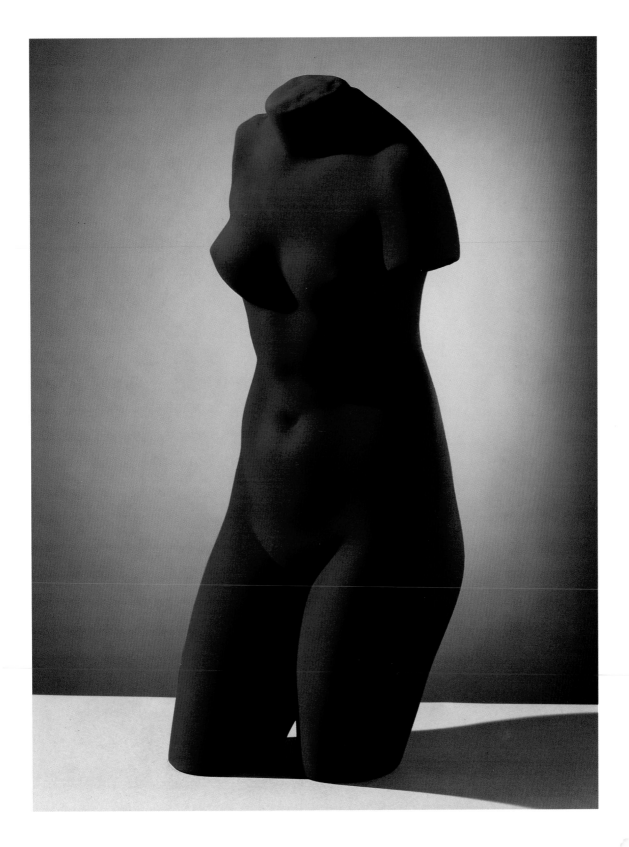

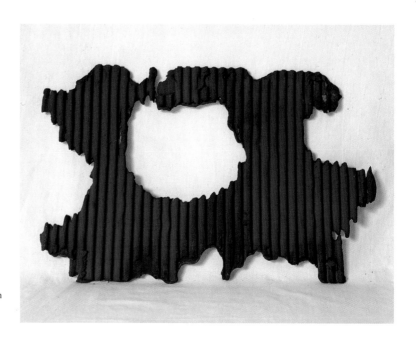

IKB 35, c. 1957
Painting with fire reflected the age-old human
dream of taming one of the most destructive
of elements.

prise Klein had in store that day. He had prepared an "empty room" upstairs,
where, going beyond pure pigment, he intended to prove "the presence of pure
pictorial sensibility in its primal state." The demonstration, to be witnessed by
a few close friends, was to take place not by means of actual examples but
through telepathy alone. The results of the test, however, initially remained undi-
vulged.

Immediately after the two-part Paris show, Klein went to Germany, where in
1948/49 he had completed his military service at a French army base near Lake
Constance. Germany was to play a crucial role in the international reception of
Klein's art, perhaps because of the climate of open-mindedness and interest in
new ideas which obtained there during the period of postwar reconstruction and
ensuing Economic Miracle of the 1950s. It was truly a red-letter day for contem-
porary art when, on 31 May 1957, Alfred Schmela inaugurated Düsseldorf's
first avant-garde gallery with a show of Klein's blue monochromes. Sponta-
neous contacts ensued with Düsseldorf members of the Zero group, who just the
month before had begun holding evening shows in the studios of Heinz Mack
and Otto Piene (and were later to extend them to that of Günther Uecker). Shar-
ing an unconventionality of approach with the group, Klein rapidly gained them
as friends and supporters in the campaign for a new art. Thanks to Norbert
Kricke, he was invited to participate in an art competition sponsored by the Gel-
senkirchen Theater, and before the night of the Düsseldorf vernissage was out,
Klein sent off his application. A year was to pass, however, before it was con-
firmed.

Two months later an encounter indirectly connected with Düsseldorf took
place, one that was to prove personally the most decisive in Klein's life. Günther
Uecker had asked his sister, Rotraut, to spend the summer at Arman's studio in
Nice, dividing her time between painting and taking care of Arman's children.
There Rotraut Uecker met Yves Klein, and an extraordinary and fateful love
began which, augmented by their artistic collaboration, was to grow deeper and
deeper over the years (p. 24). When their son was born, just a few months after
Klein's death in 1962, the relationship was continued beyond the life they had
shared together.

IKB 22, c. 1957

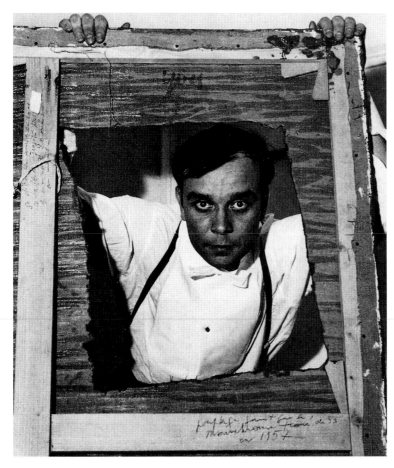

Klein with a monochrome canvas of 1957.
Always considering himself a painter of
space, Klein noted, "And let's be honest – to
paint space, I have to put myself right into it,
into space itself."

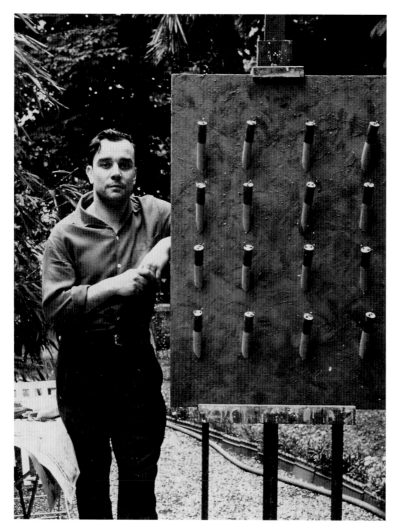

Klein in Colette Allendy's garden, with *Bengal Flares M 41 – One-Minute Fire Painting*, 1957

To recapitulate, the year 1957 marked the breakthrough of Klein's art on the European scene. At the time, this represented an extraordinary success, despite the misinterpretations – and overinterpretations – by which it was accompanied, and which Klein recorded in his journal as a chapter of contemporary history. He also documented the breakthrough in quite literal terms, in a photographic self-portrait showing him gazing through a hole cut in a monochrome canvas painted earlier that year (p. 27). With some justification he was now able to state, "I have left the problem of art behind me."

For Klein, the color blue always held associations with the sea and the sky, where the phenomena of vital, tangible nature appear in their most abstract form. "Blue has no dimensions," he noted. "It 'is' beyond the dimensions of which other colors partake." This unqualified "being" of blue was to provide the inspiration for the next phase of Klein's development, in which, conceiving of himself as a painter of cosmic space, the limits of both space and time would have to be overcome. "And let's be honest," he later said, "to paint space, I have to put myself right into it, into space itself."

PAGE 29:
Bengal Flares M 41 – One-Minute Fire Painting, 1957
"My first fire painting was a surface of Bengal flares with blue flames."
Yves Klein

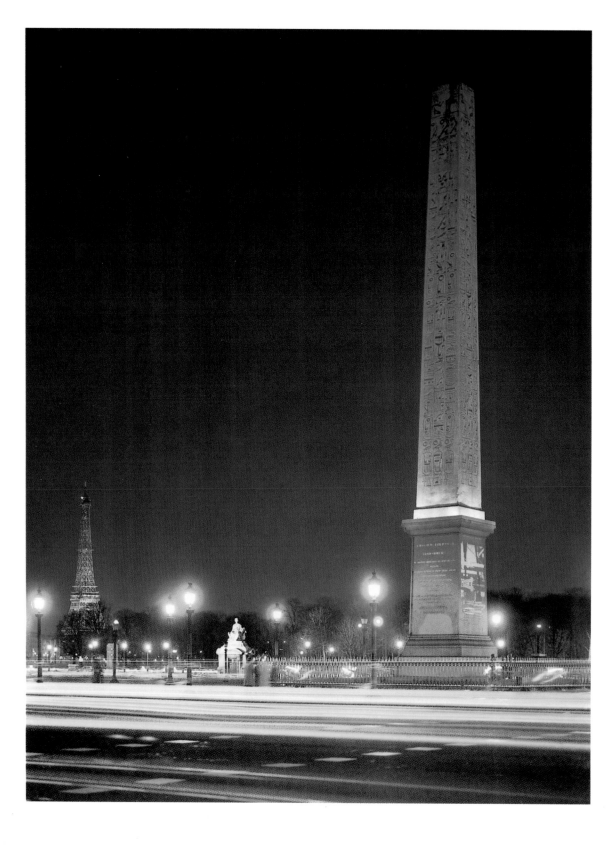

"With the Void, Full Powers"

In the early months of 1958, Klein's conviction grew that the idea for a work of art was more important than the actual, executed work itself. With great care and precise timing, he began to plan an event of a kind that no exhibition space had ever before witnessed. He intended to demonstrate the paradox that such a space could be entirely divorced from the ordinary, mundane realm of objects. As the logical consequence of the development of his painting to that point, Klein decided to exhibit nothing – at least nothing that was immediately visible or tangible. The presentation would be devoted neither to an abstract idea nor to a concrete thing, but to the *indéfinissable*, the indefinable in art, as Eugène Delacroix had called it, or the "immaterial," Klein's own term for the ever-present but ineffable aura possessed by every great work of art. As always, he chose the public setting of an art gallery for the event, which was to take place within the conventional time limits of an exhibition. With the invited guests, Klein hoped to share his new sense of universal artistic freedom, and to perpetuate it in a ritual celebration.

The exhibition, originally called "Epoque Pneumatique", but since generally known as *Le Vide* (The Void), took place on 28 April 1958, at the Galerie Iris Clert in Paris. Many legends have since arisen concerning the elaborate and painstakingly organized ritual of that evening. It truly represented an attempt to conquer uncharted territory, to capture absolute blue in empty space – "the far side of the sky."

To accompany the vernissage, a highly visible symbol was planned, a "blue project" in which the obelisk on Place de la Concorde was to be illuminated by blue floodlights (p.30). While the pedestal was to remain in darkness, the soaring obelisk would hover over the city like a magic invocation of the past (p.31). However, the successful trials carried out by Electricité de France did not convince the prefect of police, who withdrew his permission at the last moment.

That evening the windows of the exhibition space, at least, shone in the inimitable *International Klein Blue*. Posted next to the entrance under a huge blue canopy were two Republican Guards in full dress uniform, gatekeepers symbolizing a rite of passage into an unknown dimension. Invitations to "Epoque Pneumatique", which was intriguingly subtitled "The Specialization of Sensibility in its Primal State of Perpetual Pictorial Sensibility," doubled as vouchers worth 1500 francs, to encourage visitors' receptiveness to the presentation. Klein had removed all the furniture, even down to the telephone, from the small, 150-square-foot gallery room. Then, clearing his thoughts of everything but a focus on "pictorial sensibility," he spent forty-eight hours painting the room white, using the same medium he used for his monochrome canvases, in order to retain the luminosity and intrinsic value of this non-color.

Perhaps it was the eccentric, not to say crazy nature of the event that led it to be eagerly awaited on the Paris scene. At any rate, it attracted over 3000 people,

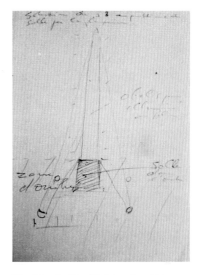

Sketch for the *Blue Obelisk* project, 1958

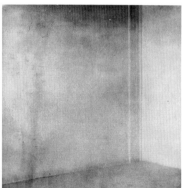

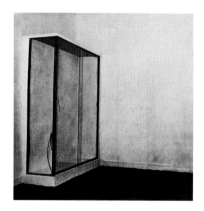

The Void, Galerie Iris Clert, Paris, 1958
Top: The walls
Bottom: Glass show-case

who, each probably expecting something different, entered the silent, empty
room individually or in small groups. They were offered a blue cocktail pre-
pared specially for the show (and later reported with chagrin that it had dyed cer-
tain bodily fluids bright blue). There was a tremendous throng on opening
night. Paris notables were deposited at the door by their chauffeurs. Two re-
presentatives of the Catholic Order of the Knights of St. Sebastian, which Klein
had joined after the Colette Allendy show, came in elaborate regalia that con-
tributed to the air of festive mystery. At a later stage in the evening, eye wit-
nesses reported, two elegant Japanese ladies in magnificent kimonos arrived.

All in all, the reactions were extremely positive and encouraging. According
to Klein, Iris Clert actually sold two "immaterial" works, and visitors felt in-
spired by the freshness of the idea. No one attempted to find parallels in contem-
porary art for *Le Vide*. Most simply accepted it as an opportunity to share an ex-
perience of the here and now, as the manifestation of a young artist's profound
vision of a life liberated from the strictures of time and space. Whether visitors
received it well or ill, Klein hoped it would bring a personal experience of art
for each and all. One, the painter Wilfredo Lam, enthused that *Le Vide* had re-
vived the "totemistic synthesis" of prehistoric times. Others spoke of a complete
break with conventional humanism, and Albert Camus reacted with a poetic
entry in the visitors' album: "Avec le vide les pleins pouvoirs" (With the void,
full powers).

As *Le Vide* was planned to coincide with the artist's thirtieth birthday on
28 April 1957, he and his family and a few close friends celebrated the end of
the remarkable event at La Coupole, a favorite artists' gathering place in Mont-
parnasse. One of Klein's birthday presents was *L'Air et les Songes*, by the

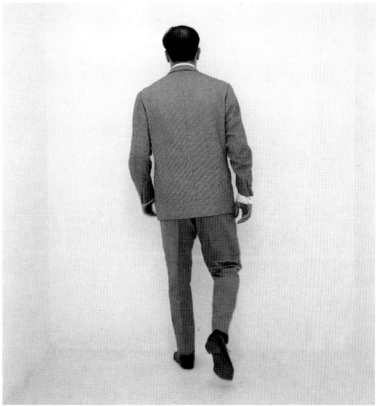

Yves Klein in *The Void*, retrospective in the
Museum Haus Lange, Krefeld, 1961
"Avec le vide les pleins pouvoirs" (With the
void, full powers), wrote Albert Camus in the
visitors' book at the vernissage of *Le Vide*,
28 April 1958

The Void, Galerie Iris Clert, Paris, 1958
Top: The walls
Bottom: Curtains at the entrance

French philosopher Gaston Bachelard, first published in Paris in 1943. Bachelard's reflections on the realm of the air, on azure blue, and on the void as the stuff dreams are made on, were later to play a key role in Klein's own writings. The climax of the evening came with a summing-up in which the artist saluted the "Pneumatic Epoch" as a historical moment in the history of art. If the "Blue Epoch" had still been informed by the Western notion of rendering the physical body spiritual, he stated, the "Pneumatic Epoch" would pursue just the opposite goal, an incarnation of the spirit as manifested in real and practical life.

In Greek philosophy, the term pneuma bore not only the general connotation of air, but the more special meaning of a gaseous substance thought to be the cause of human breathing, and thus a vital principle, or soul-force. In Christian theology and Gnosticism, those moved by the Holy Spirit were said to have received its breath, been infused with its "pneuma". Apart from these implications, Klein used the term in his speech in a political sense, to mean a conscious emanation from himself into the world around him. The illumination of the obelisk, underscored by the idea of a "Blue Revolution" he proposed that evening in Montparnasse, were first steps towards an interim government to oversee a re-organization of the world. Klein took this vision so seriously that he soon advanced the idea to no less an authority than President Eisenhower (p. 35). Artists, believers, and scientists, he stated, should join forces to lend the world a new, more humane hue, a different radiance.

Next day, an enthusiastic review of the show appeared in the daily *Combat*. Even the general public, primed by three years of monochrome art, seemed willing to accept Klein's notion of the immaterial with an open and contemplative mind. Despite its élitist tinge, the brash self-confidence with which the artist

defended the idea was hard to resist. Even Pierre Restany was astonished at the positive response. But for weeks afterwards, he reported, his invitation text had brought him the reputation of being an oddball mystic. It ran: "Iris Clert invites you to honor, with your entire spiritual presence, the bright and positive advent of a new era of experience. This demonstration of perceptual synthesis will facilitate Yves Klein's pictorial quest for ecstatic and immediately communicable emotion."

Le Vide has inspired many and diverse interpretations, probably for the very reason that its content was so difficult to describe in words. For Klein, it marked a watershed in his life and philosophy. With a Promethean conviction of the importance of his mission, he proved that his concern lay not with aesthetic issues but with the quality of the artist's mental stance. This naturally placed great demands on the viewer's habitual perception, and required a degree of emotional empathy which was perhaps unprecedented in art. With baffling logic and radical consistency, Klein had begun to override the boundaries between subjective and objective values, opening up an unheard-of potential for the artist to embody himself in his art. By means of an art that, although merely verbally proclaimed, was ritualized down to the last detail, an art that with time would be inexorably reduced and concentrated solely in the medium of his own persona, Klein sought to make painting an integral part of human life, beyond conventional dualisms. Disregarding formal, aesthetic issues, he was concerned solely with finding answers that would further an evolutionary development. "Merely saying or writing that I have overcome the problems of art is not enough," he stated. "You really must have done so. And I have done it. For me, painting is no longer a function of the contemporary eye – it is a function of the only thing in us that does not belong to us: our LIFE!"

Arman preparing his exhibition *Le Plein* (Abundance), 1960
In response to Klein's *Le Vide*, Arman packed the Galerie Iris Clert from floor to ceiling with objects, making it impossible to enter the room.

The relationship between art and life, always one of the central themes of painting, had traditionally been characterized by the personal bond between an artist and his work. In Klein's case, a concentration on the œuvre gradually gave way to an immersion in a universal, all-encompassing sensibility. After initial explorations of the full range of color, he reduced his palette to the single color of blue. Then, taking what seemed to be the only logical step, he embraced the concept of the void. This, to his way of thinking, was no mere vacuum or empty space; it represented a state of openness and liberty, a kind of invisible force-field. In addition, it was pervaded by a fundamental element, air, or pneuma, the medium of the energy the space contained. Klein's notion of a pneumatic space as a medium charged with energy, including that of human consciousness, was diametrically opposed to the concept of confronting matter with more matter, as demonstrated by his friend, Arman, a year later. In reply to *Le Vide*, Arman exhibited *Le Plein* (Abundance), filling the entire room of Galerie Iris Clert from floor to ceiling with an accumulation of objects (p. 34).

STRICTLY CONFIDENTIAL
ULTRA SECRET

"THE BLUE REVOLUTION"
Movement aiming at the transformation
of the French People's thinking and
acting in the sense of their duty to
their Nation and to all nations.

Paris, May 20th, 1958

Address: GALERIES IRIS CLERT
3, rue des Beaux-Arts,
Paris - Vme.

Mr. President EISENHOWER
White House
Washington, D.C. - U.S.A.

Dear President Eisenhower,

At this time where France is being torn by painful events, my
party has delegated me to transmit the following propositions:

To institute in France a Cabinet of French citizens (temporarily
appointed exclusively from members of our movement for 3 years), under
the political and moral control of an International House of Represent-
atives. This House will act uniquely as consulting body conceived in the
spirit of the U.N.O. and will be composed of a representative of each
nation recognized by the U.N.O.

The French National Assembly will be thus replaced by our
particular U.N.O. The entire French government thus conceived will be
under the U.N.O. authority with its headquarters in New York.

This solution seems to us most likely to resolve most of the
contradictions of our domestic policy.

By this transformation of the governmental structure my party
and I believe to set an example to the entire world of the grandeur of
the great French Revolution of 1789, which infused the universal ideal
of "Liberty - Equality - Fraternity" necessitated in the past but still
at this time as vital as ever. To these three virtues, along with the
rights of man, must be added a fourth and final social imperative: "Duty!"

We hope that, Mr. President, you will duly consider these
propositions.

Awaiting your answer, which I hope will be prompt, I beg of you
to keep in strict confidence the contents of this letter. Further, I
implore you to communicate to me, before I contact officially the U.N.C.
our position and our intention to act, if we can count on your effective
help.

I remain, Mr. President,

Yours sincerely,

The "Blue Revolution", letter to President Eisenhower, 1958
Unnerved by the turmoil in current French politics, Klein suggested to the American president that the forgotten ideals of 1789 could be revived by a peaceful revolution, in which the National Assembly would be replaced by a popular, interim government under international control.

Page from Klein's journal, 1958
As if warning himself against the dangers of hubris, "humility," Klein wrote, and again "humility."

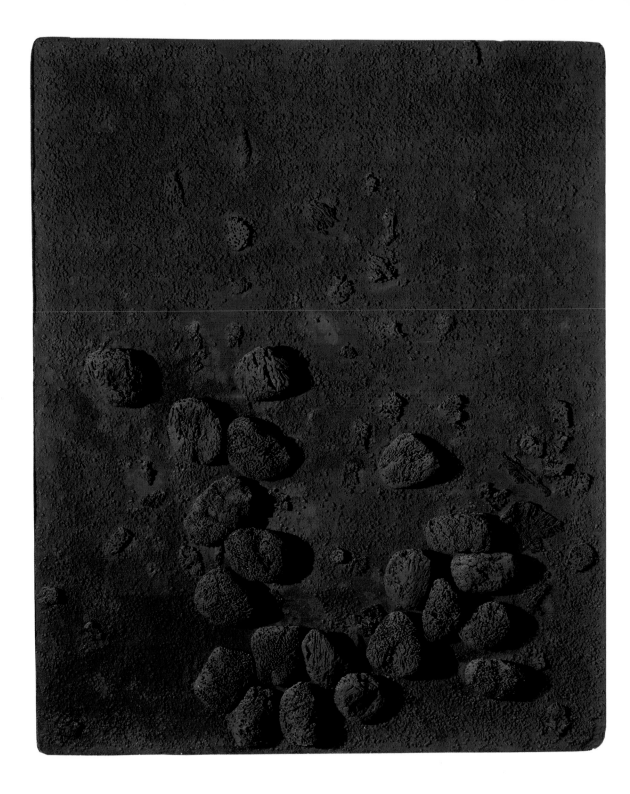

The School of Sensibility

Before deciding to use only rollers for paint application, Klein had worked with natural sponges. These he purchased, from 1956 onwards, from his friend Edouard Adam, who also supplied him with the specially developed ultramarine pigment, and who is still one of the major retailers of artists' materials in Paris.

One day Klein was struck with the beauty of a sponge soaked with blue paint, and spontaneously pressed it onto the canvas. "When working on my pictures in the studio, I sometimes used sponges," he noted in a text for his 1957 show with Colette Allendy. "Naturally they turned blue very rapidly! One day I noticed how beautiful the blue in the sponge was, and the tool immediately became a raw material. The extraordinary capacity of sponges to absorb everything liquid fascinated me." At about this time Klein created his first, small-format sponge reliefs, as designs for the decoration of a theater foyer in Gelsenkirchen, Germany. Then, in 1958, in collaboration with Vallorz and the Swiss sculptor Jean Tinguely, a close friend since *Le Vide*, he discovered a way to conserve sponges with the aid of polyester resin. The technical prerequisite for the creation of large-scale murals had been found.

The sponge as an organic growth, impregnated with his own, unique blue, seemed to Klein a perfect illustration of an "impregnation with pictorial sensibility," since sponges were naturally predestined to serve as vehicles for another, pervading element. The "Blue Epoch" exhibitions in Paris and London included a large, blue sponge sculpture, resembling a tree or a head mounted on a pedestal. The sponges, Klein explained, were intended to suggest a portrait of the viewer, a testimony to a state of interpermeating intellectual or spiritual levels. As a natural phenomenon, the sponge could be taken as a symbol of the gently alternating phases of such vital rhythms as breathing in and out, or of the transition between waking and dreaming, leading to the deep sleep that promises immersion in a timeless wisdom. Klein's *RE 16*, a large-format blue sponge relief of 1960, was inscribed *Do, Do, Do* – the singsong incantation with which French mothers lull their children to sleep. The artist had always yearned to return to a life in which homo sapiens, instead of considering himself the center of the universe, would recognize that he was merely a part of the universal design.

In the teachings of the Rosicrucians, which had preoccupied Klein since his youth, the sponge symbolizes the oceanic scope of diverse spiritual realms. This metaphor is even apt in a scientific context, for sponges illustrate a process in which the brittle remains of a once-living organism are capable of absorbing and containing great amounts of water, an element in continual flux.

Klein's reliefs are composed of saturated sponges of various size mounted on rough-surfaced panels, to create an effect evocative of the ocean floor or the topography of some unknown planet. The monochrome ultramarine blue of the compositions emanates a profound serenity, and seems to charge the surrounding space with its vibrations. On protracted view, the color is even capable of inducing a sort of waking trance. A similar state of profound mental equilibrium

Klein with a sponge relief, Gelsenkirchen, 1957–1959
Saturated with deep, monochrome blue, the reliefs seemed to charge the surrounding space with color vibrations, emanating a profound tranquillity.

PAGE 36:
RE 19, 1958

RE 20, Requiem, 1960
The feel and texture of natural sponges, and especially their ability to absorb and hold liquids, prompted Klein to use them both as working tools and as constituent parts of the painting surface.

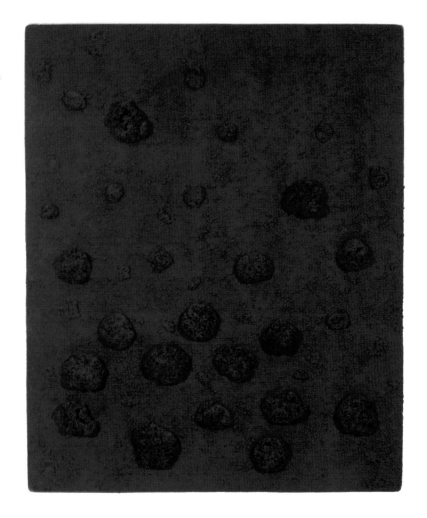

has been described by many artists and scientists of the past – and even by modern astronauts – as a source of inspiration. Richard Wagner, like Yves Klein an adept of Christian Rosenkreuz's esoteric Rosicrucianism, described the experience as follows: "I receive very distinct impressions in this trance-like state, which is a necessary condition for every creative effort. I feel that I become one with this vibrating energy, that it is omniscient, and that I can draw upon it to an extent limited only by my own, personal capabilities."

In the years 1957 to 1959, Klein's range of activities expanded when he was invited to collaborate in the project for a new theater and opera building in Gelsenkirchen. Music, drama, and the idea of a *Gesamtkunstwerk* combined to inspire the artist's first sponge reliefs on a scale that, for the period, was no less than gigantic. It is tempting to compare this organic material with Klein's intellectual curiosity, his ability to absorb impressions and impulses from the most diverse fields, and to translate them into highly personal and innovative visual forms. Unhesitatingly taking his bearings from the greats in philosophy and art – anachronism was not a word in his vocabulary – and recalling how important languages and music had been in his upbringing, Klein began to discover an affinity with Germany in general, and Wagner in particular. But in looking for some precedent to aid him in the ambitious interior design project, he did not

turn to that country's great modern architectural tradition, as might have been expected. Instead, he recalled the profound shock he had felt on seeing the frescoes in the Basilica of St. Francis, in Assisi, his first experience of Giotto's intense blue. It was this that convinced Klein that the quality of blueness was boundless, immeasurable.

As he was working on the Gelsenkirchen murals, Klein made several trips to Italy, to see the Giottos again. In these, he wrote in 1958, "the tiny, narrow gateway of world, if there is one, opens – a detail that, like all worlds, contains the signs of greatness. Greatness resides in the miniature. In Gelsenkirchen, incredible as it may seem, I have tried to create miniatures in my 20 by 7 meter paintings. This is why their relief in color can be seen to set the blue in motion, to stir it up and excite it." Then he told the theater construction committee, "I think it is justifiable in this regard to speak of an alchemy of painting, developing out of the paint material in the tension of each instant. It gives rise to a sense of immersion in a space greater than infinity. The blue is the invisible becoming visible."

The building's architect, Werner Ruhnau, had put together an international team of artists for the project, a first in Germany which the city administration

RE 24, 1960

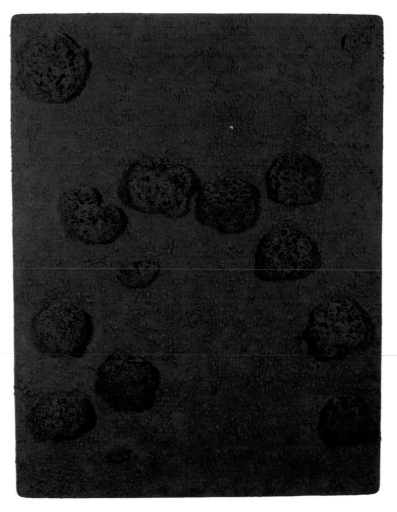

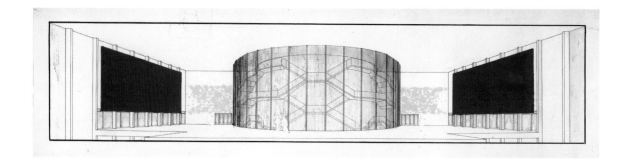

Design for the walls of Gelsenkirchen Theater and Opera House, 1958
Klein was one of the team of international artists recruited by architect Werner Ruhnau to assist him in the construction project.

was initially reluctant to accept. The team included the two German artists Paul Dierkes and Norbert Kricke, Robert Adams of Britain, Jean Tinguely of Switzerland, and Yves Klein of France. Despite difficulties at the start, the shared commitment and reciprocal influence Klein experienced during the two-year project – in which he was assisted by Rotraut Uecker, who came from Nice – opened new horizons for his art. These included a confirmation of his concept of artistic collaboration, which was partially inspired by the tradition of medieval building guilds, and plans with Ruhnau to develop what they called an "Aerial Architecture" and a "School of Sensibility."

The inauguration of the theater in December 1959 amounted to an official triumph of monochrome art. The space of the two-story foyer was dominated by Klein's blue, emanating from two enormous blue reliefs on the side walls (20 x 7 m each), two adjacent reliefs of layered sponges on the rear wall (10 x 5 m each), and two further blue relief murals in the cloakroom (9 m in length). Overjoyed by the results, Klein said he had succeeded in conjuring up a magical atmosphere for the theater audience.

The project was followed, in 1959, by another exhibition with Iris Clert, a series of bas-reliefs embedded in a forest of sponges. From this point onwards, *Sponge Sculptures* (pp. 44 and 45) and *Sponge Reliefs* (pp. 36–39), versions of which he later produced in red and gold (pp. 46 and 47), played a role in Klein's œuvre rivalling that of the monochrome paintings.

The same period saw the conception of a *Sculpture Aéro-Magnétique*, a sponge sculpture floating freely over the base, as part of Klein's plans for an artistic conquest of the air. In analogy to aeronautics and space-travel, he believed, the potential energy contained in the atmosphere could be exploited for artistic ends. Similar conceptions of space and time were being advanced by many international artists of the period, including Jesus Raphael Soto and Yaakov Agam (both also represented by Iris Clert), by Lucio Fontana, and subsequently by the Zero group in Germany and kinetic artists worldwide.

To work out his ideas of "Aerial Architecture" and a "climate-controlled earth," Klein had found the ideal partner in Ruhnau, who was receptive to his long-cherished vision of a union of humankind with the cosmos. First steps in this direction were taken with various designs for an architecture consisting of air, water, and fire. Klein explained the joint project in a now-famous lecture, "Conférence à la Sorbonne" (cf. p. 48): "In the course of all of these investigations into an art aimed at dematerialization, we met, Werner Ruhnau and I, when we discovered aerial architecture. The final obstacle that Mies van der Rohe was not able to overcome disturbed [Ruhnau] and caused him difficulties – the roof, which separates us like an umbrella from the sky, from the blue of the sky. And I was bothered by the [wall] surface – the tangible blue on the canvas – which prevents people from gazing constantly at the horizon. This dream-like state of static trance was probably experienced by humans in the biblical Eden. Human

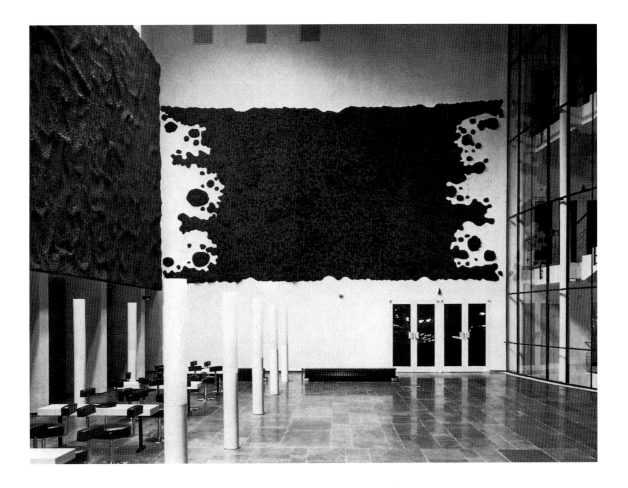

Foyer of Gelsenkirchen Theater and Opera House, 1959
In a triumph of monochrome art, Klein installed six large-scale blue reliefs in the spacious, two-story foyer.

beings of the future, integrated in total space, participating in the life of the universe, will probably find themselves in a dynamic state like a waking dream, with an acutely lucid perception of tangible and visible nature. They will have achieved complete physical well-being on terrestrial earth. Liberated from a false conception of their inner, psychological life, they will live in a state of absolute harmony with invisible, insensible nature; or in other words, with life itself, which has become concrete by a reversal of roles, that is, by means of rendering psychological nature abstract."

As with Ruhnau, Klein had once before felt a sense of immediate mutual understanding with another artist: Jean Tinguely, whom he met in April 1958, on the occasion of *Le Vide* (p. 42). Tinguely, who had been making electromechanical kinetic reliefs since 1953, was so impressed by *Le Vide* that he returned day after day to spend time in the "empty" room. The friendship between the two artists soon developed into a close artistic collaboration. Although their first kinetic object, intended for the Salon des Réalités Nouvelles of May 1958, refused to work, a few months later they were already able to mount a joint exhibition of recent pieces.

"Vitesse pure et stabilité monochrome" (Sheer Speed and Monochrome Stability) took place in November 1958, at the Galerie Iris Clert. As invitations, Klein made a number of blue disks for a motor base by Tinguely which, spinning them at 2500 to 4500 revolutions per minute, engendered a virtual blue vibration in the air. The effect of the objects in the show depended on a reciprocal

Yves Klein / JeanTinguely
S 19/17, Space Centrifuge, 1958
Top: Static state
Page 43: Kinetic state

Yves Klein and Jean Tinguely, Paris, 1958
"Yves Klein le Monochrome is a proud
assailant
He acts for no reason at all
and with great strength and suppleness
Overthrower of the established order
Brilliant architect
Great maestro and very beautiful insane ideas
The best comrade
The best challenger I have ever found
A great poet; very rich, concentrated,
and absolutely companionable
Pounding on air and truly alive
A very great inventor,
logical and absurd
and effective and human and
pleasant and antifascist,
but never 'anti' otherwise
A very good painter
A great sculptor
Long live Yves –
Jean Tinguely
12 Oct. 67"

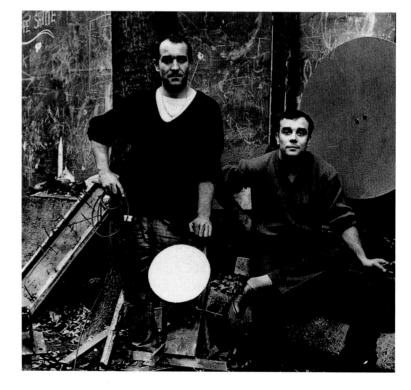

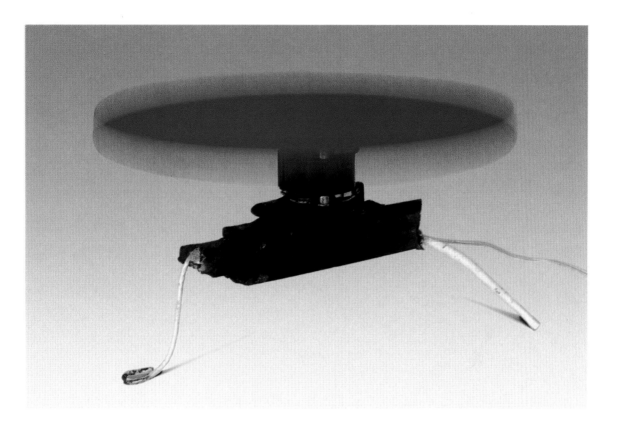

potentiation of paint support and mechanical apparatus, as in *Monochrome Per-forator* with its red disks, or in *Space Centrifuge* itself (pp. 42–43), which was rendered even more dramatic by blue sparks thrown off by the overheated motor beneath the spinning disk.

In the joint projects to follow, Tinguely was responsible for conceiving the space in terms of "the stasis of speed," while Klein concentrated on a dissolu-tion of color by means of mechanically produced vibrations. Many of their ideas never left the drawing board, such as a *Hovering Tube Sculpture*, a tube filled with helium or hydrogen which was to be suspended in a magnetic field a cer-tain distance above the floor, and which, when heated, would emit blue air into the surrounding space. Then there was a model of a *Pneumatic Rocket*, an air-driven projectile that would blast off the earth never to return. Both projects were intended to appropriate "the great space of sensibility, sheer atmosphere, the experience of a space in which there is nothing of a material character."

In January 1959, at the opening of a Tinguely exhibition at the Galerie Alfred Schmela, Düsseldorf, Klein held a momentous speech. Advancing the hypo-thesis of an evolution in art, he outlined an unwritten pact among gifted artists, and people gifted at the art of life – anyone, as Klein often said at the time, who had "a head and heart." Yet despite his longing for congenial company, he conti-nued to insist on staking out his own personal territory of ideas. He had done so years before in the case of Arman and Pascal; later, while relinquishing to Nor-bert Kricke the elements of water and light, Klein would retain sole rights to air and fire. Similar lines were drawn following the Gelsenkirchen project, and sub-sequently in negotiations with the Zero and Nouveaux Réalistes groups.

Yet in March 1959 the collaborative hypothesis could still issue in a project, a "School of Sensibility," undertaken with Werner Ruhnau and a number of close

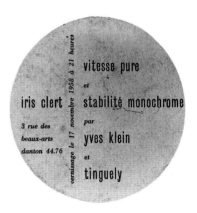

Invitation to "Sheer Speed and Monochrome Stability", by Yves Klein and Jean Tinguely, 1958

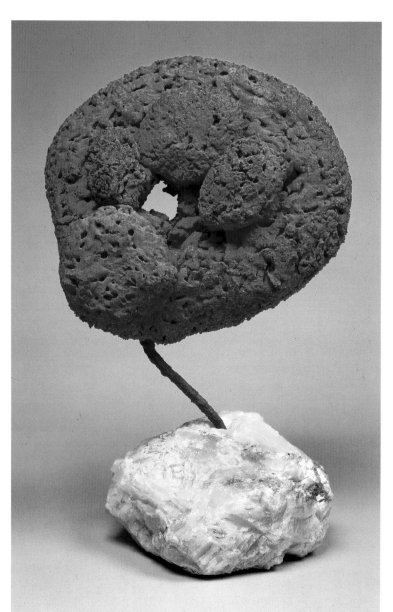

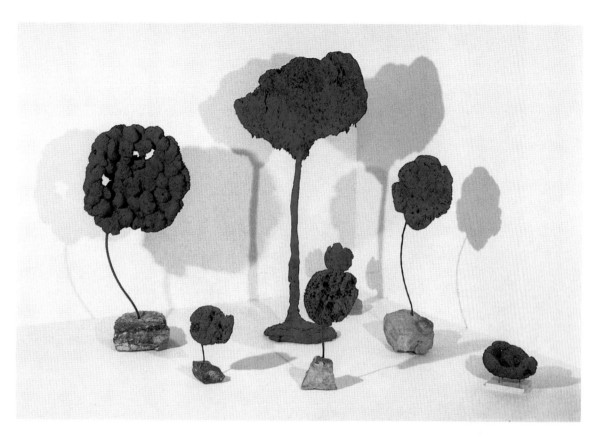

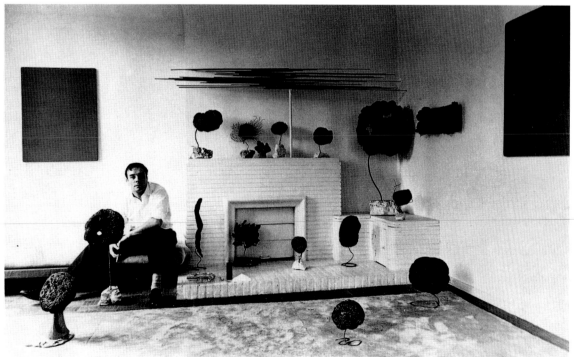

*RE 33, **The Gilded Spheres**,* c. 1960

RE 26, 1960

friends. Directly related to the notion of aerial architecture, this utopia of global togetherness aimed at altering the climate in certain regions of the planet such that human beings, freed of all ballast, could return to a paradisal state (p. 60). Klein dreamed of a world without divisions, something akin to a lush Mediterranean garden with a stable, warm climate created by taming the elements of fire, water, and air, and integrating them with that of earth. The requisite machinery, he thought, could be relegated to the planet's interior. But the people who would live this new life were a different problem. They would need preliminary training, in a program that combined the best of two medieval traditions – that of chivalry and that of the travelling artisan – to ensure imaginative and intelligent political leadership. The school's program, including a detailed curriculum, list of faculty, and preliminary cost calculation, began as follows:

"School of Sensibility and Dematerialization

"The influence of this center upon the environment is intended to reawaken the capacities of personal responsibility, and to make the attainment of higher, spiritual, and immaterial qualities, rather than [the production of] ever greater quantities, the goal of human activity.

"To find life, at the promptings of heart and mind; to imperceptibly imbue and transform human beings and their environment with, and by means of, imagination. The purpose [of the school] is to make existence in God's world unproblematic; its goal is liberty. The direct and indirect influence of this center of sensibility will be exerted by teachers who live in the midst of the student body. The habitat is a school built of immaterial architecture, pervaded by light and suffused with sensibility."

Such ideas, amounting almost to a belief in mass levitation, at least for the select few, were fueled by the promise of global change which many saw in the early successes of space technology at the close of the 1950s. After the first manned space flight in 1961, when Russian cosmonaut Yuri Gagarin reported that, from space, the earth looked like a deep blue ball, Klein was profoundly impressed, and felt his vision had been confirmed (cf. p. 83).

The more extreme, as it were externalized the ideas behind his art became, the more internalized, in the reality of his own consciousness, its manifestations grew. Finally, they largely took the form of what Klein called "pneumatic rituals." One is put in mind of some inadvertent visitor from outer space, wandering naively through an unfamiliar and even antagonistic world, yet guided by a supreme sense of the quality, beauty, and fascinating strangeness it has to offer.

Paris, 3 June, 1959. Klein at the Sorbonne, giving a lecture on "The Evolution of Art Towards Immateriality." All art starts from calligraphy, but only on condition that it be overcome...

PAGE 49:
Obelisks: S 33 Blue, S 34 Red, S 35 Gold, 1960

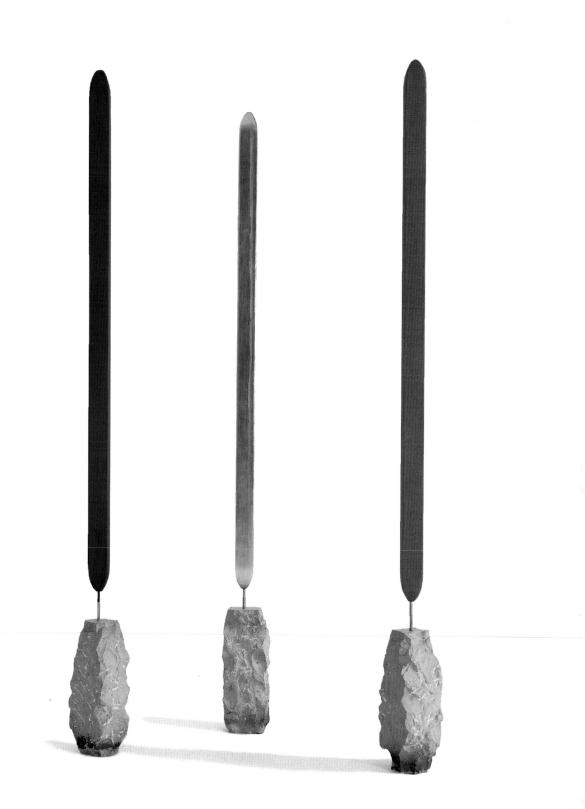

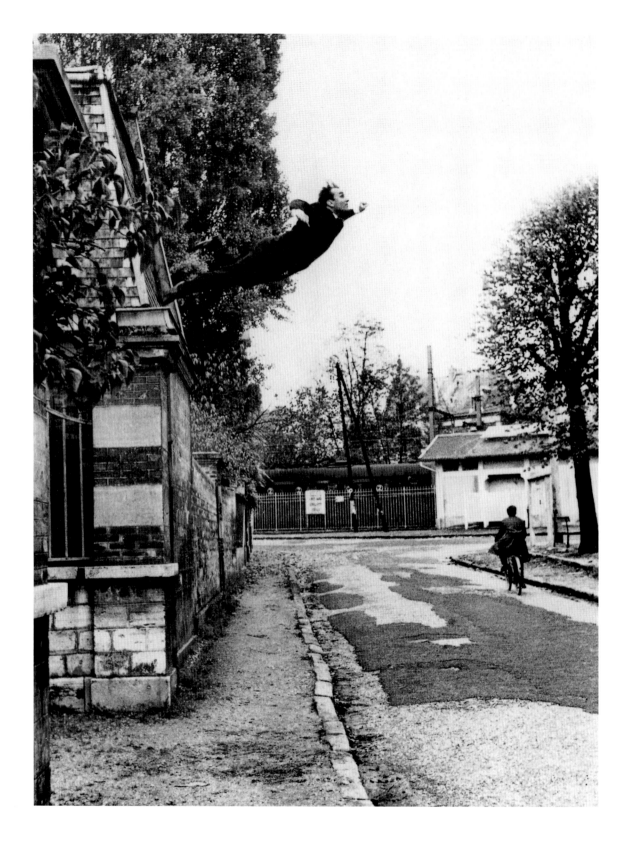

The Leap into the Void

With his *Leap into the Void*, subtitled *Man in Space! The Painter of Space Throws Himself into the Void!* (p.50), Klein stage-managed a portrait of his artistic universe. Based on a photograph taken in 1960 by Harry Shunk, on Rue Gentil-Bernard in the Paris suburb of Fontenay-aux-Roses, this collage image rapidly became a visual icon of mid-twentieth century art.

Three years previously, in 1957, Sputnik I had been launched into orbit, the first man-made satellite to circle the earth. Space-flight had spectacularly overcome the law of gravity, and to many, this promised a release from man's inexorable, earthbound fate. Seen in this context, Klein's image of a man taking a daredevil, apparently suicidal leap through the air – created a year before the first manned flight to the moon – takes on a highly evocative visual significance. The photomontage *Man in Space* revived memories of mankind's age-old dream of being able to fly; and it also reflected the Zeitgeist of contemporary art, with its optimistic belief in the potentials of the future.

Its publication was occasioned by an invitation on the part of Jacques Poliéri to participate in a performance at the third Paris Festival of Avant-garde Art, at the Palais des Expositions on Porte des Versailles. Recognizing a publicity opportunity, Klein invented a newspaper devoted to the "Theater of the Void" in which he amazingly insinuated his extraordinary self-portrait into the title page of a big Paris daily (p.51). The paper was a faithful replica of the *Journal du Dimanche*, the Sunday edition of *France-Soir*, dated Sunday, 27 November 1960. In it Klein described, in a pastiche of a reporter's style, his previously unpublished theatrical scenarios as a ritual for a proposed World Theater Day. Several thousand copies of the paper were printed on the presses of *Combat*, and distributed to Paris newspaper stands with the help of friends. Apparently it sold quite well.

Even in view of today's global network of high-speed electronic communications, Klein's crafty exploitation of the media remains remarkable. Published thirty years ago, his self-portrait *Leap into the Void* opened up new terrain for an art of pure imagination. The authenticity of his statement on the dream of flying makes it clear why Klein not only became the pioneer of 1960s European art par excellence, but the secret star of the 1970s and 1980s internationally. Joseph Kosuth hailed him as the founder of conceptual art; the Fluxus movement, happenings, performances, and body art, each in its own way, was structurally related to his work. What these streams had in common was an incentive to discover a mode of creativity that transcended national frontiers, to define its aesthetic criteria, and to disseminate the results. In this process, Klein figured in the classical role of emissary, heralding a new culture to come – invisible to the eye, yet universally present nonetheless.

"What is sensibility? That which exists outside of our being, yet which still always belongs to us. Life does not belong to us; but we can buy it with the sensibility we do possess. Sensibility is the currency of the universe, the cosmos, the

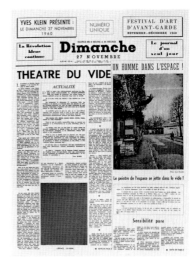

Dimanche, Newspaper for a Single Day, 27 November 1960

PAGE 50:
Harry Shunk
Man in Space! The Painter of Space Throws Himself into the Void!, 1960
The dream of flying is one of the oldest fantasies in human history. With his *Leap into the Void*, Klein appropriated it for his personal reality, and at the same time produced a self-portrait of his artistic universe.

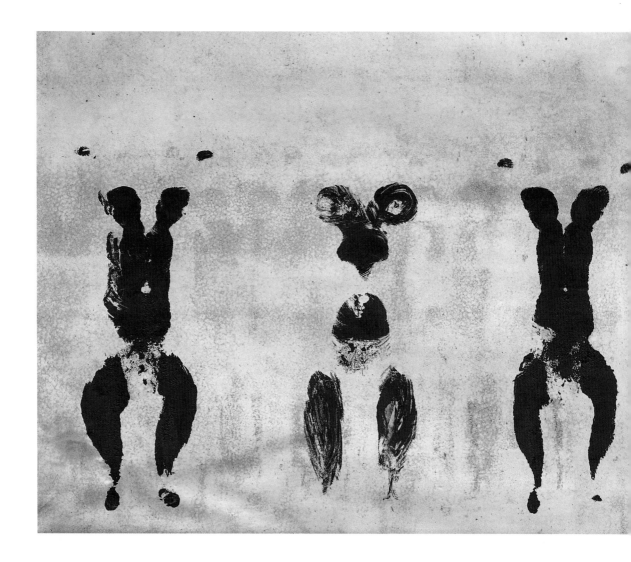

natural design, which permits us to purchase life like a raw material. Imagination is the vehicle of sensibility. Borne by imagination, we arrive at life, life in essence, which is the absolute art." Yves Klein's analysis of the principles of twentieth century art was voiced in 1959, at a time when few were willing to lend it credence.

Until 1959 Klein had supported himself largely by teaching judo, and reputedly the judo friends who had helped him practise his leap into the void were there on the street that day to catch him. The idea for a new series of works, the *Anthropométries*, can surely also be related to judo, in particular to the imprint left on the mat when a fighter falls. Klein's first experiments in the new medium date back to 27 June 1958. At the apartment of his friend and fellow judo master, Robert Godet, he applied blue paint to a nude model and helped her roll across a sheet of paper placed on the floor. The results, however, apparently dissatisfied Klein. The paint traces relied too heavily on the workings of chance, like the action painting of Georges Mathieu, which was the current Paris vogue. Klein considered this style too spontaneous, precluding the factor of conscious design. Still, the idea of working with "living brushes" continued to haunt him.

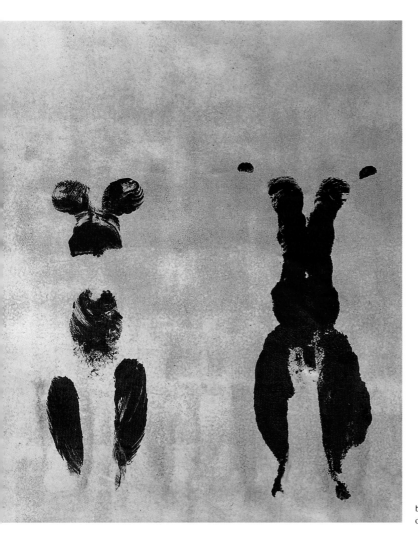

block of the body – that is, the torso and part of the thighs – that fascinated me."

The public premiere took place on the evening of 23 February 1960, in Klein's apartment at 14, rue Campagne-Première. Present were Pierre Restany, Rotraut Uecker, and Udo Kultermann, an art historian. At a sign from Klein, the model, Jacqueline, undressed, and Rotraut applied a blue pigment emulsion to her breasts, belly, and thighs down to her knees. Then, under the artist's supervision, the model pressed herself against a sheet of paper affixed to the wall (pp. 52–53). It was Restany who exclaimed, "Why, these are the anthropométries of the Blue Epoch!" giving the new imagery a title. The forms of the female body were reduced to the essentials of torso and thighs, and an anthropometric symbol – that is, one related to the canon of human proportions – was produced. Klein thought it the most concentrated expression of vital energy imaginable. The impressions, he said, represented the very "health that brings us into being." They were a means to capture life through traces left by a living human being, who was present in a work which simultaneously transcended personal presence.

As Klein's projects grew ever more ambitious – Restany spoke of a "cosmogonic efflorescence of his vision" – further contacts and adequate funding be-

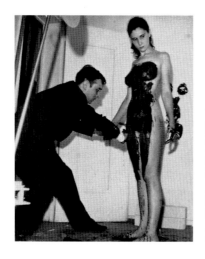
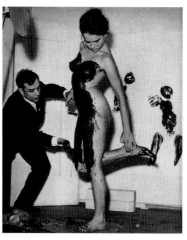
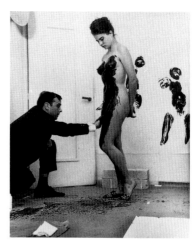

Performance of *Anthropométries of the Blue Epoch*, 9 March 1960

The performance took place at Galerie Internationale d'Art Contemporain, Paris. As the orchestra played his *Monotone Symphony*, Klein applied paint to three nude female models, then indicated where they were to press themselves against the canvas affixed to the wall.

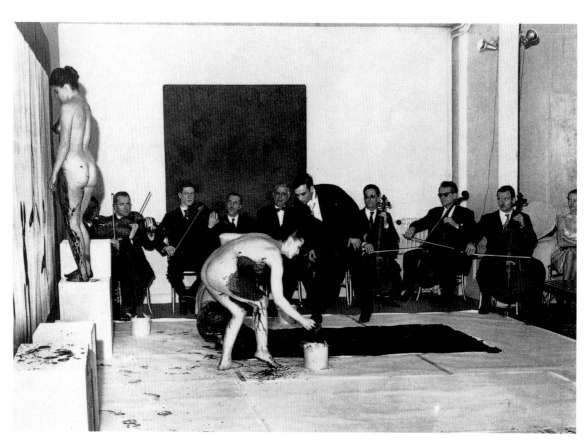

came necessary, which ultimately led to a break with Iris Clert. From this point on, Klein relied for international support and backing on the skills of art dealers Samy Tarica, Jean Larcade, and George Marci.

The first gallery presentation of the *Anthropométries of the Blue Epoch*, which took place on 9 March 1960 at Galerie Internationale d'Art Contemporain (p. 54), caused a sensation. The gallery's owner, Comte Maurice d'Arquian, was known for his major exhibitions of contemporary art in Paris and Brussels, including shows, in Paris, of such internationally successful artists as Georges Mathieu, the Arnaldo brothers, and Giò Pomodoro. The dignified atmosphere of the Rue Saint-Honoré gallery provided a perfect setting for the serious, if somewhat hazardous, proposal of combining nude models and a twenty-piece classical orchestra in a single event. After impassioned, late-night debates with Klein, the eccentric connoisseur finally agreed to present the Anthropométries as a dramatic performance – but only on condition that the soirée would not be public, that formal dress would be de rigueur, and that the invitations were to be subject to the prior approval of the Cercle d'Art Contemporain, of which d'Arquian was founder.

When the invited guests had taken their seats, Klein, in black dinner jacket and white tie, gave the cue, and the orchestra began the *Monotone Symphony* (this time comprising a twenty-minute-long continuous note, followed by twenty minutes of silence). As the sound permeated the room, three nude girls entered, carrying pails of blue paint. Klein proceeded to apply it to their bodies, and with an extreme concentration matched by the nervous tension of the audience, directed the making of the blue imprints as if by telekinesis. The performance, demonstrating for all to see the way in which sensuality can be sublimated in the process of artistic creation, engendered a mood of almost magical suspense. Yet as soon as the long forty minutes were over, a lively debate about the function of myth and ritual in art struck up, with Georges Mathieu and Yves Klein at its center.

In the wake of this event Klein was to produce over one-hundred and fifty Anthropométries (abbreviated ANT) on paper, and about thirty on unprepared silk known as *Anthropométries Suaires (ANT SU)*, or *Shrouds*. The works differed widely in terms of size, technique, and form. The smallest measured 27.5 by 21.5 cm, and the largest, *Scroll Poem* of 1962, 148 by 78 cm. The morphology of the image depended on the anatomy, temperament, and emotional state of the model involved. Based on the position and character of the imprint, the Anthropométries can be categorized as static or dynamic, positive or negative. Apart from the positive imprints mentioned, there are negative images, made by spraying paint around the model to produce a silhouette effect (pp. 60–61). Occasionally the two techniques are combined. Common to all of this imagery is its character of an immediate, physical document, lacking all trace of the artist's hand, but created according to his precise verbal instructions in the course of a public or private ritual.

In addition to single imprints from the model in a frontal position (p. 56, bottom right), or from the side, in a crouching or seated position, compositions of several imprints were also made. While some of these were done from a single model, by superimposition (p. 56, bottom left), often in combinations of blue, red, gold, and more rarely, black, others employed several different models. A juxtaposition of such imprints (pp. 52–53) engendered a sense of rhythmical movement, dance-like sequences, or incorporeal hovering (p. 63). The multi-figure compositions culminated in the great *Batailles*, battlefields of an ecstatic transubstantiation.

Down to the year 1961, the central theme of the *Anthropométries*, particularly the large formats, remained that of weightlessness. This theme can be traced back to the primeval magic rituals evoked in the cave-paintings of Lascaux, which to Klein suggested the liberating idea of life in an anonymous, technologi-

Model during the performance of ***Anthropométries of the Blue Epoch***, 1960
"The form of the human body, its lines, its color between life and death, do not interest me; I am solely concerned with its affective atmosphere. What counts is the flesh…! True, the whole body consists of flesh, but its essential mass is the trunk and thighs. This is where the real universe is found, latent creation."
Yves Klein

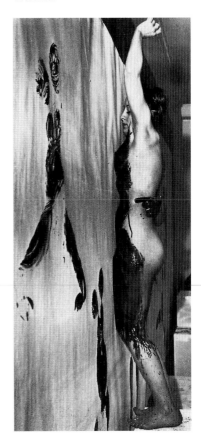

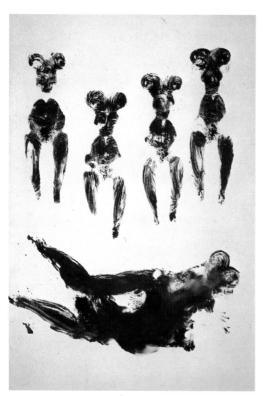
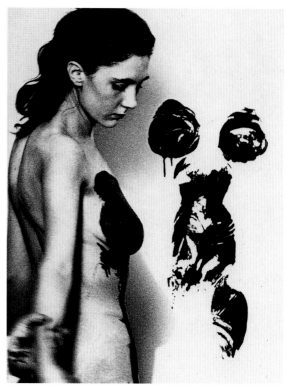
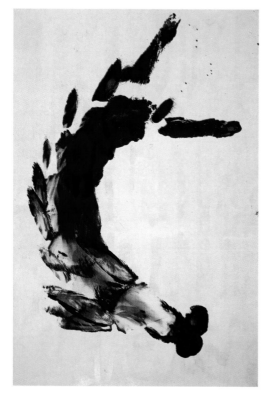
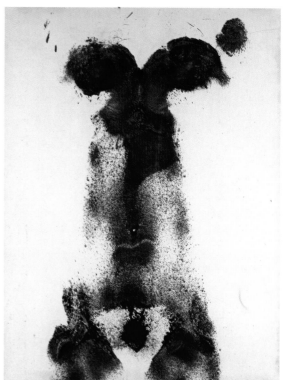

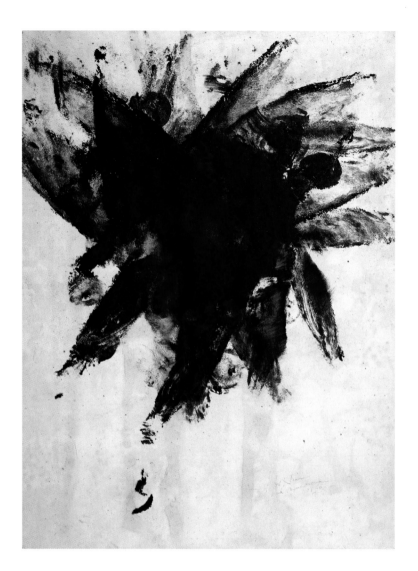

Top left: *ANT 74*, 1960
Top right: Painting with a "living brush"
in Klein's studio
Bottom left: *ANT 64*, 1960
Bottom right: *ANT 13*, 1960

ANT 73, 1960
Characteristic of the entire series is its employ-
ment of paint traces produced without the aid
of the artist's hand, but according to his pre-
cise verbal instructions. The morphology of
the imagery depends on the anatomy, person-
ality, and mood of the model involved.

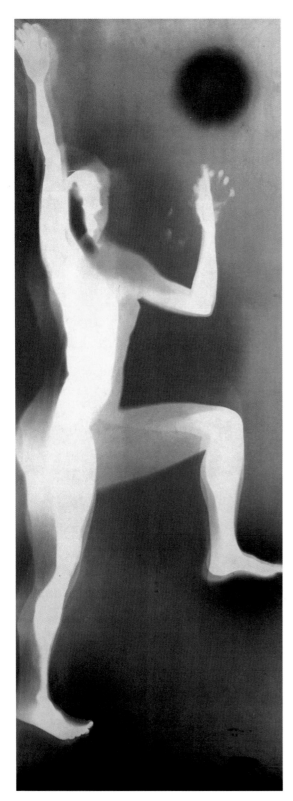

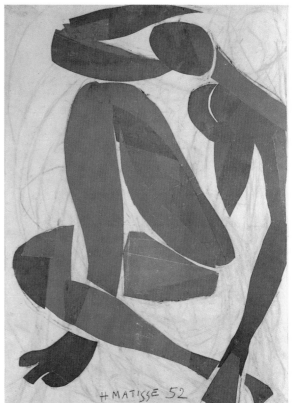

TOP:

Henri Matisse
Blue Nude IV, 1952
Towards the end of his life, Matisse developed a simplified, semi-abstract, and compelling figuration, in freehand cutouts that preserved his creative verve and whose effect relied largely on the color blue.

LEFT:

Robert Rauschenberg
Female Figure, 1949/50
In 1949/50, Rauschenberg used blueprint paper to make a series of large-format body prints in which the figure was modulated by light-rays filtering around its contours and by the model's movements. The effect of a dematerialized silhouette is reinforced to the point of seeming weightlessness by the blurred translucency resulting from the medium.

PAGE 59:

ANT 54, 1960
In 1960, not even critics who accused Klein of a return to conventional figurative art could remain entirely immune to the force of imagery made with a "living brush." Fellow artist Jesus Raphael Soto put it in no uncertain terms: "No other artist has succeeded in presenting such a puissant figuration."

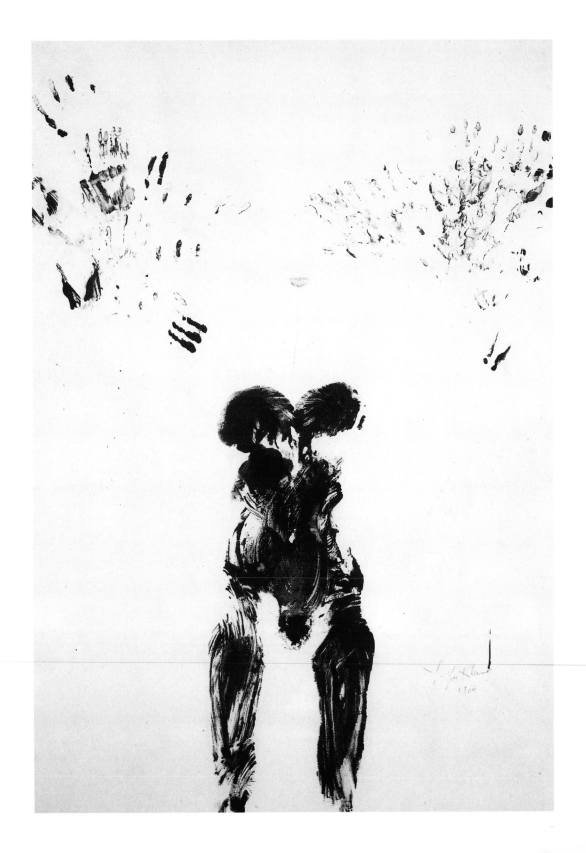

"L'acclimatisation de l'atmosphère à la surface de notre Globe"

... la conclusion technique et scientifique de notre civilisation

est enfouie dans les

entrailles de la terre et assure

le confort par le contrôle absolu du

Climat à la surface de tous

les continents, devenus vastes

Salles de séjour communes.

..... C'est une sorte de retour à l'éden
de la légende. (1951.)

.. Avènement d'une société nouvelle, destinée à
subir des métamorphoses profondes dans sa
Condition même. Disparition de l'intimité
personnelle et familiale. Développement
d'une ontologie impersonnelle.
 La volonté de l'Homme peut enfin
régler la vie au niveau d'un
 "merveilleux" constant.

L'Homme libre,
l'est à tel point, qu'il
peut même léviter !
Occupation : Les loisirs.
.. Les obstacles autrefois subis dans
l'architecture traditionnelle sont
éliminés.

Sous du corps par des Méthodes

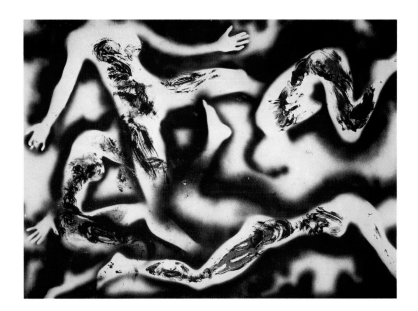

ANT 63, 1961

PAGE 60:
***ANT 102, Aerial Architecture**, 1961*
With his utopian vision of an "architecture of the air," which would eliminate the obstacles set up by traditional architecture, Klein lent shape to his dream of contributing to global reconciliation and harmony.

cal paradise. In *Aerial Architecture* of 1961 (p. 60), he symbolically outlined his entire program for taming the earth's climate, including changing weather and environmental conditions. Beneath a cluster of palms evoking the Garden of Eden, a female figure reclines on jets of air issuing from the ground, as other figures float around her in a kind of galactic space.

Between the two large, foreground figures runs a handwritten text that states the premises of aerial architecture: "The climatization of the atmosphere on the surface of the globe. The technological and scientific results of our civilization are concealed in the entrails of the earth, and assure comfort by means of an absolute control of the surface climate on all continents, which have become vast, communal living rooms… It is a sort of return to the Eden of legend (1951). Advent of a new society, destined to bring about profound metamorphoses. A disappearance of personal and familial privacy. The development of an impersonal ontology. Human will-power at last in a position to regulate life at the level of a permanent 'miracle'. Man liberated to the point of being able to levitate! Occupation: leisure. The obstacles raised by traditional architecture have been eliminated."

This utopian vision of an architecture built of sheer energy reflected a new facet of Klein's dream of contributing to global reconciliation. Looking back to the age of innocence, he yearned for a humane, if technologically and economically advanced paradise on earth. He would undo the temptation of Eve, that fateful bite into the apple that brought a knowledge of good and evil, and the resulting dichotomy between conscious and unconscious, which Klein viewed as an illogical confutation of mind and matter. In Restany's eyes, the great, weightlessly hovering *Anthropométries* of the artist's two final years contained "the allusive trace of anti-matter in matter."

This interpretation applies in a special way to a large-format work indicatively titled *Hiroshima* (p. 62). Its technique alone makes it unique, for this is the only Anthropométrie of the final years to consist solely of negative impressions. The composition is built up of silhouettes in various poses, shadowy blue figures that appear to levitate in deep blue space. Here the presence of the flesh is transmuted into its reverse, the absence of mass death, the ghostly traces of a memory indelibly engraved in the world's mind.

For an entire generation of young artists who had been confronted with the appalling possibility of atomic catastrophe, embodied in the photographs of Hiroshima that shocked the world, a new awareness of life-supporting energies had become imperative. It was no longer enough to come to terms with artistic tradition; the future had insinuated itself into artists' lives with an immediate and unparalled poignancy. To many, a utopian leap seemed the only way to break the bonds of the past, in the hope that someday, somewhere, they would be able to breathe free.

Seen in this light, *The Leap into the Void* and subsequent *Anthropométries* mark a watershed in Klein's work after 1960. In current psychological parlance, it might be termed an "ego transformation" which engendered a new peak of creative activity. Klein's great strength and persuasiveness lay in his unshakable conviction that artists were capable of looking beyond cause-and-effect relationships on the material level of sensory perception, to detect previously untapped sources of sheer creative energy. These sources, he thought, could be made accessible to everyone, through a mental sensitization which could involve a great variety of approaches and experiences. In Klein's view, the Anthropométries represented one such vehicle of true, real, life-enhancing powers, and not merely, as critics argued, a return to figurative art (pp. 58 and 59). Imagery of this type could be produced only by creative collaboration among people who had agreed to perform a shared ritual, without personal or direct contact.

When we look at *Humans Begin to Fly* of 1961 (p. 63), we see a series of silhouetted figures apparently hovering in an indeterminate space, above or before the actual painting surface. In iconographical terms, the image recalls the tradition of depictions of angels, which, like the falling Satan, figure in classical art theory as symbols of the human dream of weightlessness. The enigmatic *Humans Begin to Fly*, like *The Leap into the Void*, poignantly conveys the idea of a harmonious self-sublimation. This derived from Klein's insight into the deeper meaning of the ancient alchemistic vision of universal levitation. "Thus we will become aerial men," he predicted. "We will literally float in a total physical and mental freedom."

ANT 79, Hiroshima, c. 1961
"Light will make us fly, / and we will see the sky from above, / everything will permeate us, / everything will pass through us / as if passing through something and nothing. / ... / will move us so rapidly / that we will become invisible and 00000000."
Günther Uecker

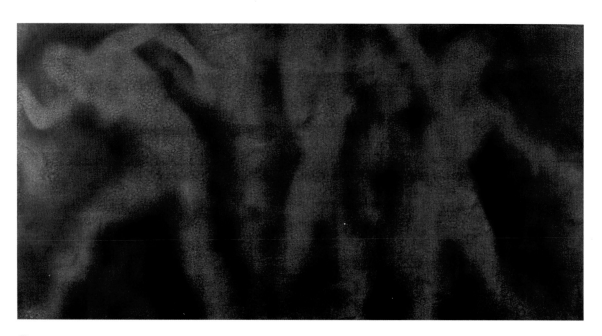

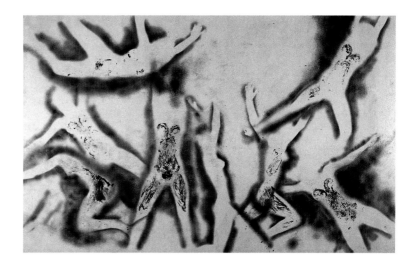

ANT 96, Humans Begin to Fly, 1961

In addition to the compositions based on female models, Klein produced, on 10 November 1960, a six-meter-long shroud titled *ANT SU 11* which employed the male figure. The imprints in this case were provided by a group of like-minded artists then making their appearance on the Paris scene, the Nouveaux Réalistes. Intended as the record of an idea impressed on empty space, the joint work was displayed on the Porte de Versailles in 1960. It was provocative enough to induce an anonymous vandal to rip off a large section at the bottom, including the artists' signatures. The work has since gone down in art history as *The Assassination Attempt.*

Despite occasional rivalries, there was an increasing trend among artists at the time to form alliances to pursue common theoretical and practical goals. Perhaps it was the spirit of the 1960s that engendered a sense of shared responsibility throughout the Western art world. Artists travelled as never before, and contemporary art expanded in highly diverse directions, as if collective wellsprings of inspiration had begun to flow for some as they dwindled for others. The result was a pervasive, general sense of innovation that transcended narrow, national scenes. By this time Klein was no longer considered a marginal avant-garde figure, but the pioneer of a modernism that was re-establishing itself throughout Europe, and infusing fresh life into the twentieth-century tradition. A focus on light and motion, on the energies contained in color, on the structure of virtual volumes, and on the conquest of a new pictorial space, led everywhere on the continent to new, fluctuating groupings and movements. These existed for a time, proclaimed their artistic credos, and then disbanded again. Yet they left behind a network of contacts, a mutual understanding that extended far beyond the established art centers. Such groups played a key role in bringing new and innovative content to European art.

With the winds of change whistling through the studios, many groups looked for self-definition in manifestos and clearly demarcated theories. In Paris, art critic Pierre Restany (p.64) formed the center of gravity for a number of artists who, for all their differences, agreed in staking their claim to "authentic realism." Combining European neo-Dadaism with certain aspects of American Pop, the group seemed to Klein a step in the right direction. It would help him realize his idea of a center of sensibility, and perhaps even foment his "Blue Revolution". On 27 October 1960, in Klein's apartment at 14, rue Campagne-Première (p.64, bottom right), Restany officially called the Nouveaux Réalistes group to life. The founding members were Arman, François Dufrêne, Raymond Hains, Yves

Pierre Restany with his book, *Yves Klein. Le Monochrome*, November 1961

BOTTOM LEFT:
Founding manifesto of the Nouveaux Réalistes: "On Thursday, 27 October 1960, the Nouveaux Réalistes became conscious of their collective singularity. New Realism = new perceptual approaches to the real."

BOTTOM RIGHT:
The Nouveaux Réalistes visiting Yves Klein: Arman, Jean Tinguely, Rotraut Uecker, Daniel Spoerri, Jacques de la Villeglé and Pierre Restany, 1960

Klein, Martial Raysse, Daniel Spoerri, Jean Tinguely, and Jacques Mahé de la Villeglé (p. 65), who were later to be joined by Niki de Saint-Phalle, Christo, and Deschamps. A founding manifesto was issued, in seven copies on monochrome blue paper, and on one sheet each of monochrome pink and gold (p. 64, bottom left).

The first full-scale public appearance of the Nouveaux Réalistes came in 1960, with an exhibition at Galleria Apollinaire in Milan. Their declared principal aim was to present reality as a "realistic work of art," with the artist's creative activity itself constituting the manifestation and actual subject of the work. The artist's sensibility, instead of lending things aesthetic shape, would express itself solely through a selection and presentation of certain existing realities. Restany, initiator and mentor of the group, also formulated its guidelines. He spoke, for instance, of an "urban folklore" and, with reference to the neo-realistic *Accumulations* of Arman and Spoerri, of "quantitative instead of qualitative expression."

In 1961, under the heading "A 40° au-dessus de Dada" (Forty Degrees above Dada), Restany mounted a collective show at his own Galerie J. Aimed at defining the intellectual position of the Nouveaux Réalistes, the show paid homage to the great achievements of anti-art and Dada, while demonstrating that these had been overcome and carried a step further. As Restany himself put it, "The fever of the Nouveaux Réalistes is the fever of poetic discovery: dadaist 'readymades' on the scale of modern miracles."

<u>Jacques de la Villeglé</u>
Rue au Maire, 1967
One of the founding members of the Nouveaux Réalistes, de la Villeglé
early discovered what he called the "poésie murale," the poetry of walls.
The texture of a peeling billboard, a décollage, frames a sheet of blue
which calls up many associations with everyday French life – cigarette
packages, police uniforms, royalist blue, or the revolutionary blue of the
tricolor – while remaining a quote from reality.

IKB 191, 1962

This blue monochrome canvas is an homage to Pierre Restany, who from their first meeting, in 1955, provided Klein's œuvre with literary and theoretical underpinning. His collaboration with the French art critic, which Klein termed an experience of "direct communication," was to materially further a general understanding of his art beyond his lifetime.

IKB 191, 1962
Reverse with dedication:
"For Pierre Restany, at the heart of the monochrome proposition,
Yves le Monochrome, 1962"

Monochromes and Fire Paintings

The year 1960 saw Klein focussing on the poignancy of color, as he supplemented his famous blue with pink and gold. The new colors now made their appearance in all of the media he had worked in – monochrome paintings, sculptures, and sponge reliefs. It was gold in particular that challenged him to new heights of technical mastery.

Klein had learned the technique of gilding in London in 1949, and was awed at the potentials of this costly and difficult material. What especially fascinated him was the fragile nature of "the exquisite, delicate gold, whose leaves flew away at the slightest breath." For the medieval alchemists, the search for a way to make gold corresponded to a search for the philosopher's stone. Their attempts to combine chemically what they called earthly and heavenly elements, apart from the pragmatic aim of transforming base metals into the most precious currency, gold, were informed by a higher, metaphysical idea – that of the enlightenment and salvation of mankind.

But to return to Klein, and to the ambitious and expensive projects for which, it should be recalled, he never had enough ready cash. Naturally this was a problem faced by many young artists, then as now. But according to Klein's friends and his wife, Rotraut, his difficulties were compounded by the fact that he was working on an ever larger scale, and could not afford to rent a studio. Yet the pressures of need evidently served to fuel his imagination still more. And, as Samy Tarica, a Paris collector, reports, Klein had a great power of persuading people that it was more than self-interest that led him to suggest a new exchange system for contemporary art that would reflect new and more sensitive forms of social interaction.

This notion drew from various value systems of the past. It reflected an awareness of the history of ideas, in which gold, beyond its material value, invariably possessed a profound spiritual and metaphysical meaning – recall the golden domes of Byzantium, or the gilt grounds of medieval painting. The aim of Klein's artistic transactions was to reinstate gold, and by analogy, money, in this symbolic function, and to break us of the habit of considering it a mere means of exchange for commodities, particularly works of art.

In a solemn ritual witnessed by museum staff, for instance, Klein sold *Zones of Immaterial Pictorial Sensibility* to friends, fellow artists, and patrons. The purchase price was to be paid in gold or gold ingots, half the value of which the artist promised to return, in one way or another, to nature and humanity, to "the mystical circulation of things."

One such transaction, photographically recorded, took place on 10 February 1962. For the surrender of "his pictorial sensibility," the Blankforts, an American couple, gave fourteen gold ingots to Klein, who thereupon threw seven of them into the Seine. The other half of the purchase price was later converted into gold leaf for his works, the *Monogolds* (p.68).

Using a specially developed technique, the fine gold leaves in these works

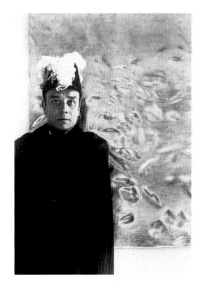

Klein in the regalia of the Knights of St. Sebastian

PAGE 68:
MG 18, 1961
Beyond its material value, gold symbolized for Klein a spiritual atmosphere that transcended all ages and cultures. His skill at handling gold leaf dated back to 1949, when he worked with a gilder in London. With blue and pink, gold was a principal color of his monochrome works.

were only partially affixed to the surface. Set in motion by the slightest breath of air, they began to tremble like light reflections on water. In some of the large-format gold panels, Klein initially sanded the wood down to produce a slightly irregular surface, leaving shallow depressions like those seen in *Monogold MG 16, Resonance* (1960; Stedelijk Museum, Amsterdam). The first official presentation of the monochrome gold series took place in 1960, at the group exhibition "Antagonismes" in the Musée des Arts Décoratifs, Paris. Displayed with the works was a receipt for a *Zone of Immaterial Pictorial Sensibility*, to underscore the direct link between Klein's "surrender rituals" and the gold employed in the panels.

Indicatively, Klein's blue-pink-gold triad derived from the colors seen in the heart of a flame. Ever since *Bengal Flares* of 1957 (p. 29), he had been searching for a way to translate the light spectrum into pigments. In his Sorbonne lecture, the transforming and unifying nature of fire played a key part (cf. p. 48). "Fire and heat," Klein stated, "are explanatory in a great variety of contexts, because they contain enduring memories of personal and decisive events we have all experienced. Fire is both intimate and universal. It resides in our hearts; it resides in a candle. It rises up from the depths of matter, and it conceals itself, latent, contained, like hate or patience. Of all phenomena, [fire] is the only one that so obviously embodies two opposite values: good and evil. It shines in paradise, and burns in hell. It can contradict itself, and therefore it is one of the universal principles."

The symbiosis of monochrome color and fire can be seen to stand for all of Klein's attempts to embody, in concrete, objective form, the subjective significance of human inspiration as a universal, shaping force in art. The culmination of the series came in 1960, with the classical triptych of three large, individual monochrome panels titled *IKB 75, MG 17,* and *MP 16* (p. 71; Louisiana Museum of Modern Art, Humlebæk, Denmark). Inspired by altarpieces, frequently tripartite in form and essentially symbolic in content, this work emphasizes the meditative, contemplative aspect of art above all others. Klein loved ceremony, especially religious rites, which he took very seriously. He made several pilgrimages to Cascia, Italy, to visit the shrine of St. Rita, to whom he had been dedi-

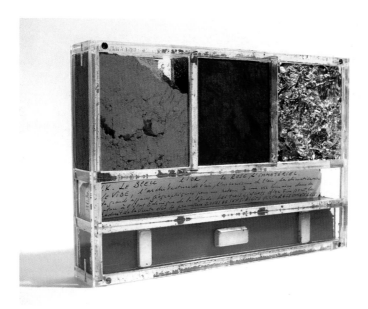

Ex Voto for the Shrine of St. Rita in Cascia,
1961
"Anyone who does not believe in miracles is not a realist." Yves Klein, quoting Ben Gurion. Klein's *Ex Voto* was rediscovered in 1980, during reconstruction work at an Italian convent. The votive offering was intended for St. Rita, whose protection and intercession the artist sought from childhood. To him, religious rituals were an essential part of a fulfilled life.

cated as an infant and continued to pray for protection. A belief in the power of prayer was a quite normal part of Klein's life and art, almost as if he had a premonition of his premature death. In a small miracle of art history, his pink, blue and gold *Ex Voto* of 1961 (p. 70) – a votive offering including a prayer for the success of his first large museum exhibition – was rediscovered by chance on 18 June 1980, during renovation work at the Cascia convent.

The blue-gold-pink triad, supplemented by his first *Fire Sculpture* and *Fire Wall*, also formed the focus of Klein's large one-man show at Museum Haus Lange, Krefeld, Germany. Initiated by the museum's then director, Paul Wember, the show opened on 14 January 1961. It was a unique chance for Klein to sum up his life's work to that point, and to give an indication of what the future held in store. The only comprehensive museum presentation of his œuvre and ideas to take place during his lifetime, "Yves Klein: Monochrome und Feuer" was accompanied by a catalogue-edition comprising one each blue, pink, and golden sheet, and a small blue sponge. Inside the building, three rooms were devoted to large-format meditative panels, in IKB blue, in a rose madder signifying the incandescent flower of blue (*RE 22, Le Rose du Bleu*), and, as the final stage of dematerialization, panels entirely in gold (p. 71). Also on display were sponge-reliefs in three colors (pp. 46 and 47), and free-standing sculptures, the *Obelisks* (p. 49). Many other, familiar works now appeared in blue, pink, and gold versions, including *Pure Pigment* of 1957, here exhibited in plexiglass containers placed on the floor (which were later produced in editions, in the form of tables).

Plans for *Aerial Architecture* and *Fountains of Water and Fire*, also on view, found their spectacular culmination outside the museum. In the garden, the ten-foot-high flame of a *Fire Sculpture* roared, fed by butane gas from underground pipes. Beside it stood a *Fire Wall* (p. 72), a grid of flickering Bunsen burners that created the impression of a hovering wall of blue rosettes of flame. In order to record the blue center of the flames, which to Klein symbolized the "burning heart," he held a sheet of paper to *Fire Wall* and *Fire Sculpture* and showed the scorched sheet in the exhibition (p. 73). With his first fire painting, Klein gave form to another age-old dream of humanity, the taming of fire. "The lighting of the flame during the vernissage," recalled eye-witness Restany, "had the moving character of a mystical event. Looking at the utterly transformed and ecstatic Yves Klein, and Rotraut imperturbable in her Egyptian coiffure, we all had the

IKB 75, MG 17, MP 16, 1960
Blue – gold – pink. Aside from the fire paintings, this monochrome trilogy was a major theme of Klein's final years. Each color had its special symbolic meaning; in combination, they represented a manifesto of the artist's creative intensity.

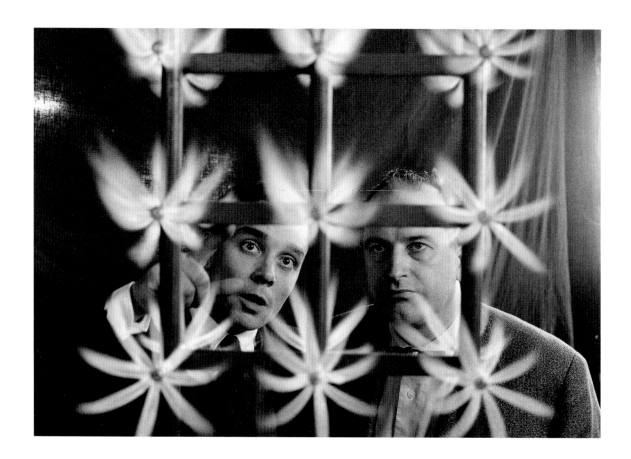

Yves Klein with the architect Werner Ruhnau
behind his *Fire Wall*, 1961

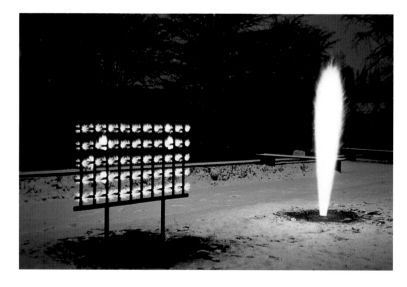

Fire Wall and *Fire Sculpture*, Krefeld, 1961
"The lighting of the flame during the vernis-
sage had the moving character of a mystical
event."
Pierre Restany

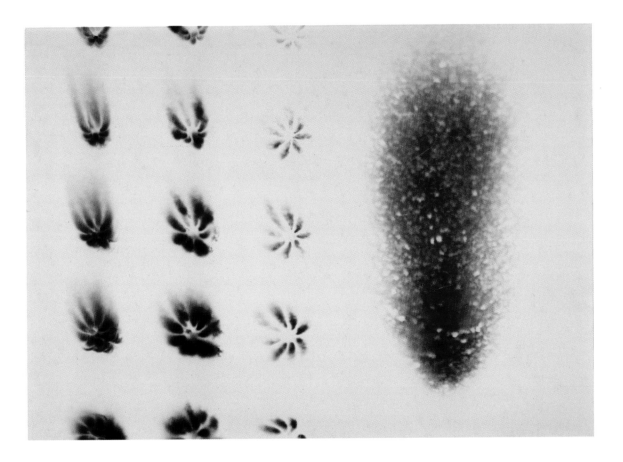

F 43, 1961

impression of taking part in the celebration of an unknown rite that nevertheless concerned us all."

In a public event marking the end of the Krefeld exhibition, the first official series of fire paintings were created. These were later authorized and inscribed by Paul Wember, in a new form of confirmation of artistic originality: "This Fire Painting was executed by Yves Klein in the presence of the public and myself, at Museum Haus Lange, Krefeld, on 26 February 1961. Krefeld, 17 July 1962." Just how important it was for Klein to distinguish his work from that of other artists may be gathered from his correspondence with Otto Piene, who had also recently begun working with fire, in the form of candle flames, to create his smoke-paintings. The two artists reached an amicable, detailed agreement, which was admittedly facilitated by the fundamentally different nature of their respective techniques.

The successful collaboration between art and industry in Gelsenkirchen and Krefeld encouraged Klein to engage in further, ambitious projects in Paris. Working in the laboratories of the Centre d'Essais du Gaz de France, he produced a series of about thirty *Fire Paintings* (pp. 74 and 75), including some in color, made with the aid of a flame-thrower on specially treated cardboard. The basic idea was closely related to that of the *Anthropométries* and *Cosmogénies* (compositions of marks left by rain and plants) – painting by means of fire imprints. Some of the multicolored imagery employed various supplementary techniques to evoke a synthesis of the four elements. That of water, for instance, was integrated with fire by moistening a nude model with water and having her make an imprint on the surface before applying the flame. Since the

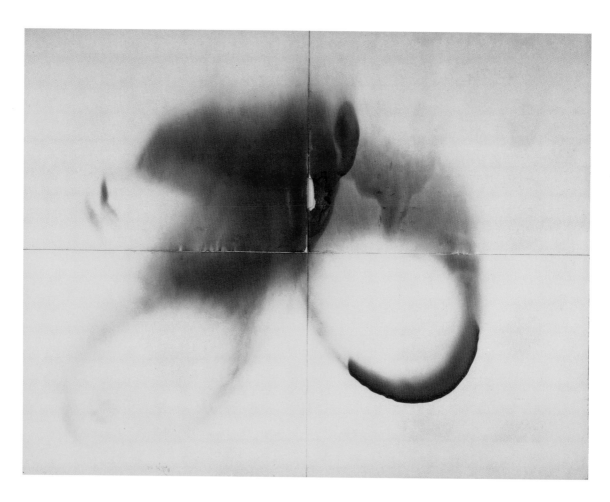

F 25, 1961
"And I believe that fires burn in the heart of
the void as well as in the heart of man."
Yves Klein

Klein working on *F 25*, 1961

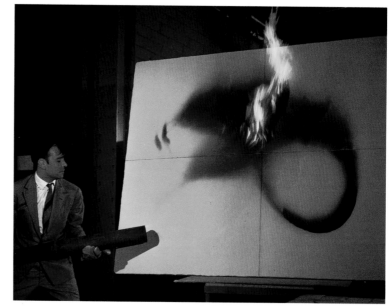

PAGE 75:
Top left: *F 36*, 1961
Top right: *F 6*, 1961
Bottom left: *F 31*, 1961
Bottom right: *F 26*, 1962

Mark Rothko
Number 101, 1961

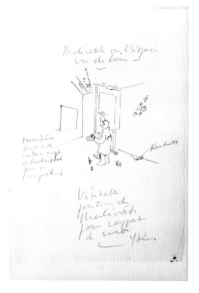

Malevich, or Space Seen from a Distance
A caricature as time-warp: Malevich, co-
founder of non-objective art, painting his
Black Square from one of Klein's blue mono-
chromes. Poor Malevich arrived at Supremat-
ism only to find his successor already there.

PAGE 77:
MP 19, 1962

damp area resisted fire longer, the imprint remained like a ghostly shadow
within the surrounding dark, scorched ground.

In one of his most compelling texts, Klein wrote in 1961 of a potential escape
from the fateful sufferings of the fire-tamer, Prometheus. Applying the legend to
himself and his own era, he said, "In sum, my goal is twofold: first of all, to re-
gister the trace of human sentiment in present-day civilization; and then, to regis-
ter the trace of fire, which has engendered this civilization... And all of this be-
cause the void has always been my constant preoccupation. And I believe that
fires burn in the heart of the void as well as in the heart of man." What is more,
in a controversial speech titled "Le Kitsch et le Corny," held in the Chelsea
Hotel, New York, in 1961, Yves Klein announced to his nonplussed hearers,
"One should be like untamed fire in nature, gentle and cruel; one should be able
to contradict oneself. Then, and only then, can one truly be a personified and
universal principle."

Klein placed great hopes in his journey to the United States, where he and his
wife, Rotraut, spent the months of April to June, 1961. He was a young and self-
confident thirty-three, New York was replacing Paris as the art center of the
world, and the legendary Leo Castelli had agreed to mount an exhibition
devoted entirely to Klein's blue monochrome canvases. After seeing it, Andy
Warhol is said to have walked out the door with the laconic comment, "That's
blue!" The reaction of the New York audience to the artist's "rather messianic
message of a typically European stamp" was unexpectedly lukewarm. I have
been able to discover only one review, in *Art News* for May 1961. With evident
detachment, the author associates Klein's blue with the blue of the sky, with the
innocence of medieval saints like St. Francis, and with the blue of Western meta-
physics and Oriental mysticism – only to conclude that, ultimately, the canvases
represented Western icons of French neo-dadaism.

Despite the muted press reaction, Klein plunged himself into a welter of activ-
ity, hurriedly composing his Chelsea talk, and arranging meetings with New
York artists. As if to bolster his self-confidence, he wrote in his journal, "For
me, this world journey already began ten years ago, though it was only this year
I decided to go to New York. My show has enabled me to make contact with all
the artists who interested me, which was what I wanted to do." He had brief but
intense meetings with key Abstract Expressionists, exchanging paintings with
some of them; he talked with Barnett Newman, Ad Reinhardt, Larry Rivers, and
Marcel Duchamp, who became a friend and later visited Klein in Paris. Only his
eagerly-awaited meeting with Mark Rothko, with whose work he felt a covert
affinity (p. 76), came to nothing, when Rothko walked past him without blink-
ing an eye (which may, of course, have had more to do with the sensitive Amer-
ican artist's growing insecurity in public situations).

As may be seen from Klein's caricature of Malevich (p. 76), he always
considered himself the first artist to conquer liberated pictorial space. Not with-
out irony, he depicted Malevich as a conventional artist, copying his famous
Black Square through the window of a blue Klein *Monochrome* on the wall. Yet
while outwardly maintaining his stance as inventor and master of monochrome
art, Klein was dismayed by the indifferent reception he received in New York.
He was not able to sell a single painting, and for the first time in his life he
began to speak of loneliness and death.

That May, Klein moved on to Los Angeles, where his show at the Dwan Gal-
lery found open-minded viewers and brought confirmation from other artists. He
met Edward Kienholz, a close friend of Jean Tinguely, who despite misgivings
purchased a voucher for pictorial sensibility. Yves and Rotraut travelled exten-
sively through the American West, at one point driving a Land Rover across the
Mohave Desert. Yves insisted on going to Death Valley, which he thought would
be an ideal place to install a column of fire. In a sense, Klein's fascination with
the idea of death, a mixture of anxiety and amusement, began in America. The

Yves Klein/Christo
Wedding Portrait, 1962
A joint venture by Klein and Christo, the portrait was done on 21 January 1962, the day of Klein's marriage. It remained uncompleted after the artist's death.

Marriage of Rotraut Uecker and Yves Klein, 21 January 1962

couple's itinerary then included their first helicopter flight, followed by a visit to Disneyland, which enormously delighted and impressed them both.

Back in Paris, Yves and Rotraut were sure of one thing – they wanted to marry. Klein proceeded to plan the wedding as if it were the most important living work of art he had ever undertaken, and detailed a magnificent rite. To the accompaniment of the *Monotone Symphony*, in a rearrangement dedicated to them as a wedding present by the musician, Pierre Henry, Yves Klein and Rotraut Uecker were married on 21 January 1962, at Saint-Nicolas-des-Champs in Paris. Rotraut wore a blue crown under her veil, and Yves appeared in the regalia of a Knight of the Order of St. Sebastian, in cloak and plumed hat. An escort of fellow knights accompanied the procession, which passed under the crossed swords of the order (p.78). The reception continued late into the night, and was enthusiastically celebrated as a union of the families of bride and groom, their friends, and fellow artists. And as regards traditional marriage rites, the extraordinary event became even more so when it was announced that Rotraut was pregnant with their son, Yves. The ceremony was recorded from beginning to end by photographer Harry Shunk, who captured its very special atmosphere as a work of art created by life. Artist-friends like Arman and Christo reacted with their own imagery (p.78), which may now be seen in the Musée d'Art Moderne, Nice.

PAGE 79:
MG 25, 1961

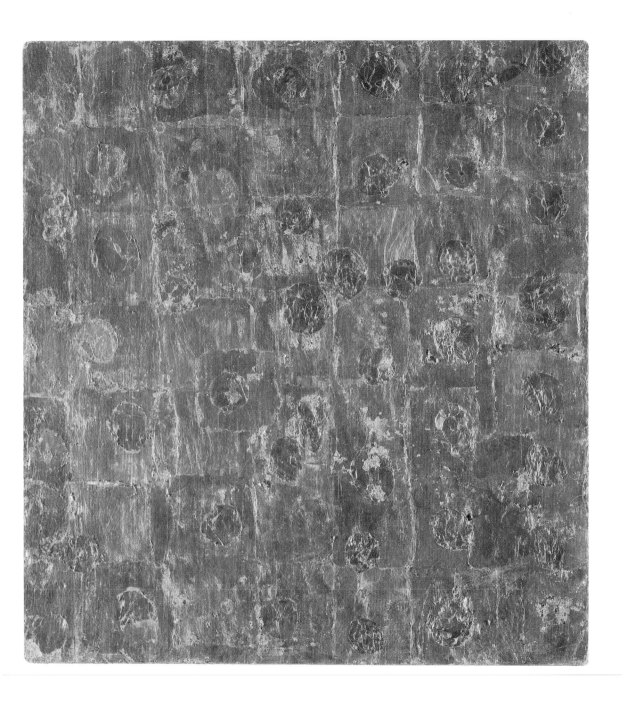

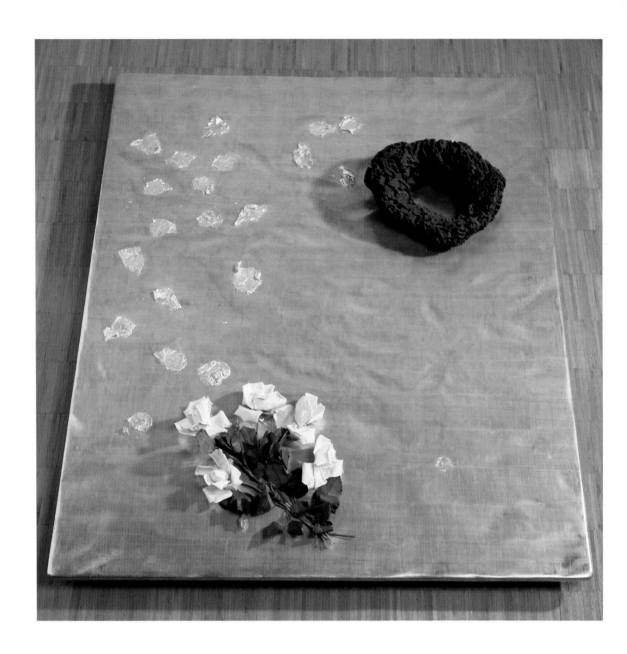

A Life like a Continuous Note

There is an early page in Klein's journal on which he wrote, in a kind of intimate monologue, the one word "humilité" over and over again (p. 35). Humility, to be sure, but not the ordinary, daily humiliations which can be so wounding to a sensitive artist. In the course of his brief life, Klein developed an extraordinary charisma. Thanks to his athletic figure and a mind receptive to the wonderful and mysterious aspects of existence, he exuded the aura of a youthful hero, like some irresponsibly innocent messenger of the gods. He seemed to move in a higher realm than ordinary mortals, which is why he could say, "My paintings are the ashes of my art." Yet although he devoted his entire œuvre to the harmony and beauty of a potential future culture, Klein himself felt continually exposed to loneliness and death. This constant awareness of mortality expressed itself in his art, as critic Ulf Linde has said, by "the presence of absence." This explains the vital importance Klein attached to having his art understood as an attempt to transcend the personal. As he stated as early as 1959, at the opening of Tinguely's exhibition in Düsseldorf: "The message I carry within myself is that of life and nature; and I invite you to participate in it, to the same extent as my friends, who know my ideas better than I do myself – because they are the many, and can reflect on them with greater diversity, because I am alone."

Newly married and at the apex of his artistic success, Klein experienced the extremes of Eros and Thanatos in rapid succession. First, on 1 March 1962, came the delicately lyrical note of a *Store-poème* (Scroll Poem). As if drawing the lines of his life together, Klein combined poetry by his closest friends, Claude Pascal, Arman, and Pierre Restany, with imprints from the model, Héléna, on a linen shroud almost fifteen meters in length. It was like a souvenir of the unique, irretrievable moments of their past collaboration. Then, a short time later, on 31 March, Klein spontaneously called a photographer in to take a picture of him lying on the floor, underneath *RP 3, Here Lies Space*, a 1960 relief evocative of the solar system (Musée National d'Art Moderne, Paris; pp. 80 and 81). In a ritual of anticipation, Klein asked his wife to scatter roses on the work of art as last resting place. Half in jest, perhaps half in a kind of magical incantation, he said he wanted his artistic spirit to partake in the myth of eternal presence beyond the grave.

In the final phase of his career, apart from spending more time with his close friends, Klein developed a new series of images relating to the earth's surface. As early as 1957, he had already conceived a *Blue Globe* with mountain ranges indicated in relief, based on the characteristic idea of capturing in art everything known, and yet to be discovered, about the planet (p. 83). Here, as in all of his subsequent imagery, Klein's prime interest lay in the phenomenology of human imagination. Out to evoke a unity of heaven and earth, he methodically developed forms of visual heightening coupled with an extreme reduction of means. At the time, this approach was completely unprecedented. And, as at every later stage of his art, it addressed the point at which the limits of percep-

Klein lying under *Here Lies Space*, 1960
The artist had this prescient photograph taken on 3 March 1962, a few weeks before his death. Half in jest, half in an attempt to ward off the inevitable, he asked his wife to scatter a wreath of roses on the grave.

PAGE 80:
RP 3, Here Lies Space, 1960

Harry Shunk
The Earth Is Blue, c. 1961
"Neither missiles, rockets nor satellites will make man the conqueror of space... Man will only succeed in taking possession of space by means of the forces... of sensibility."
Yves Klein

tion become manifest. Take the visionary *The Earth Is Blue* of 1961 (p. 82), where by concentrating his mental powers on a *Blue Globe* Klein virtually liberates the earth from its poles, its constricting antipodes, to make it hover in space.

Klein loved to investigate enigmatic, metaphysical phenomena, and he had the gift of realizing his visions in act and image. He would not have been the artist he was if he had allowed his creativity to play itself out within the confines of tradition and habit. The strange, ecstatic nature of his work speaks even to those who view it with a certain detachment, for it conveys a sense of truths beyond common sense. And unlike the comparatively cerebral approach of Duchamp, Klein's anthropomorphic emphasis seems to lend his work a solid core of meaning. It conveys the feeling of an artist endeavoring to create, or recreate, a dynamic harmony, in which the sensory potentials of human beings might once again be sharpened to the point of being able to recognize, in what they habitually consider the external world, the same benevolent, basic order at work as in their own physical organism.

After his vision of the earth as a blue planet was confirmed by Yuri Gagarin's message, Klein as it were returned home again from his universal adventure. To-

RP 7, *Blue Globe*, 1957

Klein visually anticipated the words of cosmonaut Yuri Gagarin, who in 1961 became the first man to orbit earth in a space capsule: "Seen from space, the earth is blue."

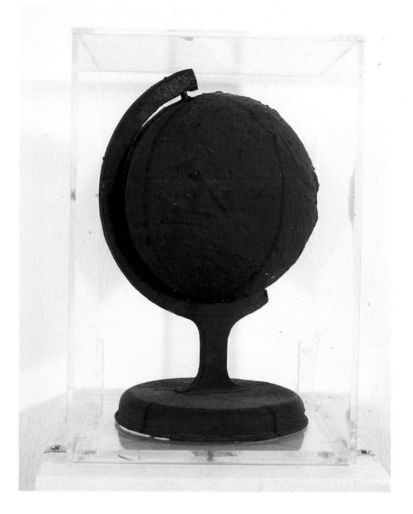

wards the end of his life he grew ever more certain that it was not an expansion beyond all limits that determined his art, for "the painter of space has no need of Sputniks or missiles to go into space; all he needs is himself" and the "forces of sensibility."

Back in Paris, Klein bought geophysical relief maps of every region of France. To make his first *Planetary Reliefs*, in August 1961, he simply painted over such maps, as in *RP 4*, which shows the area around Grenoble. Towards the end of the year he began making plaster-of-Paris casts of the maps and coloring them ultramarine blue. An example is *Planetary Relief RP 18* (p. 85), a topographical image of France as a whole. In addition to blue reliefs of the earth's surface, Klein also made one each based on the moon and Mars, tinted a monochrome pink to symbolize the fires at work in the eternal genesis of the universe. A further, planned series of galactic reliefs was never executed.

These last surviving records of the artist's voyages of discovery are suffused with curiosity about the world of which we are a part, and yet know so little. They take us to lucid, dizzying heights, and at the same time into the obscure depths of the human subconscious. As if in possession of a phoenix-like power of continual rejuvenation, Klein again and again found visual formulations for

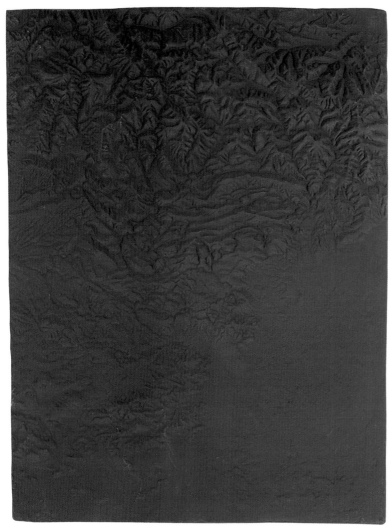

RP 10, 1961
"I have chosen as my ally the palpable space of the entire, boundless universe. This is the first time that anyone has taken it into account. It's like finding the master key."
Yves Klein

the contemporary age which were situated at that borderline where borders dissolve and the known merges with the unknown. "Art... is not some inspiration that comes from who knows where, takes a random course, and presents nothing but the picturesque exterior of things. Art is logic *per se*, adorned by genius, but following the path of necessity, and informed by the highest laws," to requote that key entry in Klein's diary for 1958.

The statement contains the essential, defining antipodes of his artistic existence. On the one hand, it describes the gratuitous nature of inspiration, which comes in a reverie only to fade again, leaving behind an intangible but lastingly illuminating aura. On the other hand, the statement refers to the logical values that inform the Western tradition, particularly the chain of cause and effect. Klein also alludes in passing to the distinction he always drew between talent and genius, the latter of which he felt at work within himself, a romantic ecstasy that led him on a quest for a present that fulfilled the highest laws.

In early 1962 Klein was entirely preoccupied with the idea of creating a Garden of Eden on earth. He envisioned a temperate zone of gardens and lakes, in-

terspersed with fire and water sculptures shooting into the air, symbolically uniting the fundamental elements. As culmination of this landscape, Klein planned a magnificent frieze along classical lines, composed of figures in a noble pose that would express the character of a more humane culture to come. These were to be based on life-size casts of himself and his artist-friends, depicted nude in a frontal, static pose, with head turned slightly aside, and arms with clenched fists resting at their sides. The figures were to end at the thighs – that is, like many of Klein's earlier pieces, to have no apparent visible support. Flanked by bronze castings of his friends in ultramarine blue before a gilded ground, his own figure would gleam at the center, in gilt bronze against blue.

Klein commenced the project in February 1962, making plaster casts of his closest and oldest friends from Nice – Arman, Martial Raysse, and Claude Pascal. The electrifying effect of the blue-gold contrast was conceived in the ancient tradition of color symbolism seen in Byzantine and Egyptian art, or in Buddhist temples. The resulting portrait reliefs, like that of Arman (p. 87), possess an extreme tension; the mutual attraction and repellence exerted by the blue and gold engender a forcefield of mental associations and emotions. While the burnished gold surface reflects everything and absorbs nothing, the matte blue of the figures causes them to recede, seemingly depriving the individuals depicted of corporeal presence. The pieces have the effect of timeless detachment, and yet the life that still clings to the empty human shell makes them magically compelling.

In sum, these final works of Klein's might be characterized as a sublimation of the personal aura, a transformation of physical sensuality into the inviolable if ineffable presence of enduring artistic values. Significantly, his *Portrait Relief of*

RP 18, 1961

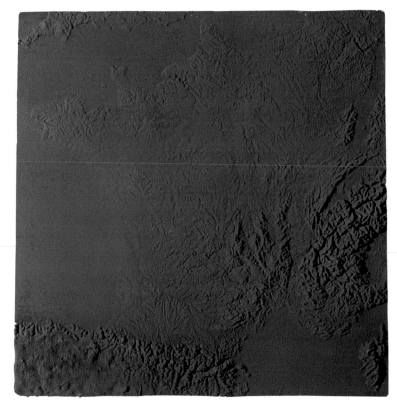

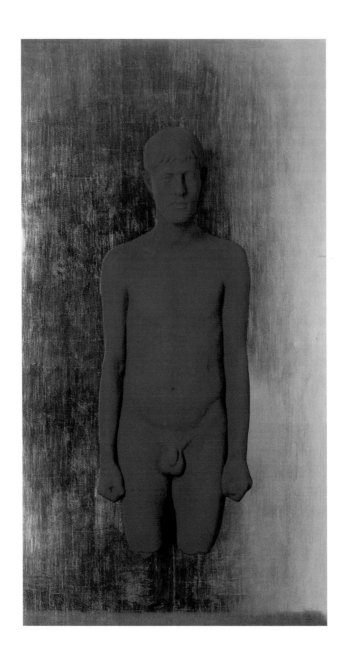

PR 3, Portrait Relief of Claude Pascal, 1962

In February 1962 Klein made plaster casts of his closest friends, Claude
Pascal, Arman, and Martial Raysse, then painted them blue and mounted
them on a gilded panel. The blue-gold contrast, familiar from ancient By-
zantine and Egyptian tradition, was consciously employed to heighten the
visual and emotional effect of the image by uniting the diverse sensations
engendered by the two colors.

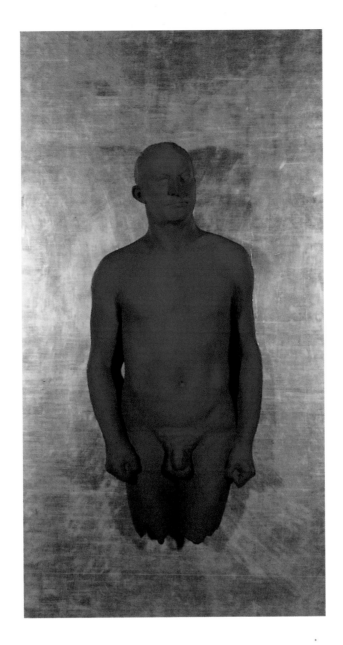

PR 1, Portrait Relief of Arman, 1962
The plaster cast of Arman was made in bronze and tinted blue. In 1968,
six years after the artist's death, it became the first work of his to be
acquired for the French national collections.

Arman became the first of Klein's works to enter a large public collection, when it was acquired by the French government in 1968. Yet it was an honor the artist was not destined to experience. His final, great project remained unfinished, an idea floating free in the space that played such a central role in his art, an idea that, like so many of his audacious and innovative conceptions, was to influence successive generations of artists profoundly.

On 11 May 1962, at the Cannes Film Festival, Klein was stricken by a heart attack. He was rushed to Paris, where only a few days later, on 15 May, a second attack followed. Then came a third, which took his life on 6 June 1962. A few months later, his son, Yves, was born in Nice.

Shortly before his death, Yves Klein entrusted these thoughts to his journal: "Now I want to go beyond art – beyond sensibility – beyond life. I want to enter the void. My life should be like my symphony of 1949, a continuous note, liberated from beginning and end, bounded and at the same time eternal, because it has neither beginning nor end… I want to die, and want people to say of me: He has lived, therefore he lives."

Klein assisted by Dino Buzzati in a ritual relinquishment of a *Zone of Immaterial Pictorial Sensibility* (Zone de sensibilité picturale immatérielle), Paris, 26 January 1962

Harry Shunk
Yves Klein, 1962
"... people should be able to say of me:
He has lived, therefore he lives."

Yves Klein – A Chronology

1928 Yves Klein is born on 28 April in Nice. His father, Fred Klein, is a landscape painter, and his mother, Marie Raymond, one of the first representatives of *l'art informel* in Paris.

1944–46 He attends the Ecole Nationale de la Marine Marchand and the Ecole Nationale des Langues Orientales, Nice. Makes his first essays in painting.

1947 Klein enrols in judo classes, and meets Claude Pascal and Arman, who will become lifelong friends. Begins experiments that will lead to the *Monotone Symphony*, and makes first monotype imprints using his hands and feet.

1948 In September, travels to Italy. Involvement with Rosicrucianism begins.

1949 Military service in Germany. Departs for England with Claude Pascal.

1950 Klein works for Robert Savage, a gilder and framemaker in London. Travels to Ireland with Pascal, where they take riding lessons with the idea of going to Japan on horseback. Klein holds his first private show of small monochrome paintings in his room.

1951–52 Further trips to Italy and Spain.

1952–53 In September, Klein travels by ship to Japan. Earns the Black Belt in judo at the Kôdôkan Institute, Tokyo. Holds a private exhibition of monochrome paintings in that city.

1954 After returning to Europe, Klein takes a teaching and supervisory post at the Spanish National Judo Federation, Madrid. *Yves Peintures* published with a preface by Claude Pascal, consisting of blank lines. Private show in Madrid. Moves back to Paris at the end of the year.

1955 A monochrome canvas is rejected by the Salon des Réalités Nouvelles, Paris. Yet Klein receives his first public exhibition, at the Club des Solitaires, on the premises of Editions Lacoste.

1956 February 21 to March 7: the exhibition "Yves: Propositions monochromes" is held at Galerie Colette Allendy. Klein joins the Order of the Knights of St. Sebastian. 4 to 21 August: represented in the first Festival d'Art d'Avant-Garde, Marseille.

1957 Klein's feverish work is rewarded by a number of shows: 2 to 12 January: "Epoca Blu", Galleria Apollinaire, Milan; the group exhibition Micro-Salon d'Avril, Galerie Iris Clert, Paris; 10 to 25 May: dual one-man show with Colette Allendy, "Yves – le Monochrome", and 14 to 23 May: with Iris Clert, "Pigment pur"; and finally, shows at Galerie Alfred Schmela, Düsseldorf, and Gallery One, London.

Klein as Knight of St. Sebastian, 1956

Klein with Black Belt of 4th Dan Judo Master, 1960

Voucher for gold value of pictorial sensibility, 1959

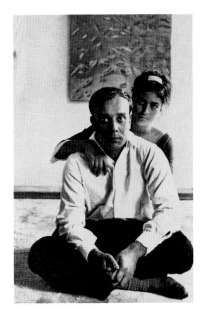

Self-portrait photograph of Yves and Rotraut Klein, Paris, 1961

Artists' and architects' collaborative: Jean Tinguely, Yves Klein, Iris Clert, Werner Ruhnau, Bro and Jesus Raphael Soto, Paris, 1960

1958 Begins designs for the foyer of Gelsenkirchen Theater, Germany, and makes first experiments with "living brushes." On 28 April, *Le Vide* opens at Galerie Iris Clert, followed, on 17 November, by "Vitesse pure et stabilité monochrome", a joint show with Jean Tinguely.

1959 Klein speaks at the vernissage of Tinguely's exhibition at Galerie Schmela, Düsseldorf. In April, he shows an "immaterial" piece in Vision in Motion, a group exhibition at the Hessenhuis, Antwerp. Contributes to a group show with Iris Clert, which opens on 29 May. 3 and 5 June: Klein holds a lecture on "The Evolution of Art Towards the Immateriality," subsequently known as "Conférence à la Sorbonne." 15 to 30 June: "Bas-reliefs dans une forêt d'éponges", Galerie Iris Clert. 7 October: Klein is present at the opening of "Works in Three Dimensions", Leo Castelli Gallery, New York. 18 November: back in Paris, he sells his first *Zone of Immaterial Pic-

torial Sensibility*, on the banks of the Seine. 15 December: attends the inauguration of Gelsenkirchen Theater, whose foyer is decorated with his monumental sponge reliefs.

1960 February: Klein participates in "Antagonismes", held at the Musée des Arts Décoratifs, Paris. March: first semi-public presentation of his *Anthropométries*, at Galerie d'Art Contemporain, Paris. April: group show "Les Nouvelles Réalistes", Galleria Apollinaire, Milan. First *Cosmogénies*. 11 October to 13 November: "Yves Klein – le Monochrome", Galerie Rive Droite, Paris. 27 October: Nouveaux Réalistes group officially founded. 27 November: "Dimanche – Le journal d'un seul jour" published with Klein's *The Leap into the Void* on the front page.

1961 14 January to 26 February: retrospective "Yves Klein: Monochrome und Feuer", Museum Haus Lange, Krefeld, Germany. Klein begins series of *Planetary Reliefs*. That

spring, he and Rotraut Uecker travel to the United States. 11 to 29 April: shows with Leo Castelli, New York. 17 May to 10 June: participates in group exhibition "A 40° au-dessus de Dada", Galerie J, Paris. 17 and 18 July: performs sequences of *Anthropométries* for inclusion in the film "Mondo Cane". Collaborates with Claude Parent on plans for water and fire fountains for the Palais de Chaillot, Place de Varsovie, Paris.

1962 21 January: Rotraut Uecker and Yves Klein are married at Saint-Nicolas-des-Champs, Paris. The artist begins making plaster casts of his friends, Arman, Raysse, and Pascal, for *Portrait Reliefs*. 1 March: creates *Scroll Poem*. 11 and 12 May: attends premiere of "Mondo Cane" at the Cannes Festival. In May, Klein suffers two heart attacks; on 6 June, he succumbs to a third. In August, his son, Yves, is born in Nice.

List of Illustrations

32 top left
Charles Wilp
Yves Klein in the Void, 1961
Photograph
Berlin, Bildarchiv Preussischer Kulturbesitz

32 top right
Le Vide, exhibition room in Galerie Iris Clert,
Paris: The walls, 1958
Photograph
Estate of Yves Klein

32 bottom right
Le Vide, exhibition room in Galerie Iris Clert,
Paris: Glass show-case, 1958
Photograph
Estate of Yves Klein

33 top right
Charles Wilp
Yves Klein in the Void, 1961
Photograph
Berlin, Bildarchiv Preussischer Kulturbesitz

33 top left
Le Vide, exhibition room in Galerie Iris Clert,
Paris: The walls, 1958
Photograph
Estate of Yves Klein

33 bottom left
Le Vide, exhibition room in Galerie Iris Clert,
Paris: Curtains at the entrance, 1958
Photograph
Estate of Yves Klein

35 left
The "Blue Revolution", letter to President
Eisenhower, 1958
Estate of Yves Klein

36
RE 19, 1958
Sponges, pigment and synthetic resin on
hardboard, 200 x 165cm
Cologne, Museum Ludwig

38
RE 20, Requiem, 1960
Requiem
Sponges, pebbles, pigment and synthetic resin
on wood, 198.6 x 164.8 x 14.8cm
Houston (TX), Collection D. and J. de Ménil

39
RE 24, 1960
Sponges, pigment and synthetic resin on wood,
145 x 114 x 13cm
New Hampshire, Collection Dartmouth College
Museum and Galleries

40
Design for the walls of the Gelsenkirchen Theater
and Opera House, 1958
Ink and paint on paper, 33 x 120cm
Private collection

41
Foyer of the Gelsenkirchen Theater and Opera House
with sponge reliefs, 1959
5 x 10 m. Gelsenkirchen, Musiktheater im Revier

42 top
Yves Klein / Jean Tinguely
S 19/17, Space Centrifuge (static state), 1958
Excavatrice de l'Espace
Blue disk mounted on electric motor, diameter 22cm
Private collection

43 top
Yves Klein / Jean Tinguely
S 19/17, Space Centrifuge (kinetic state), 1958
Excavatrice de l'Espace
Blue disk mounted on electric motor,
diameter 22cm
Private collection

44
SE 207, 1959
Pigment and sponge mounted on stone base,
height 45cm
Japan, private collection

45 top
Sponge Sculptures, 1960–1962
Sculptures éponges
Pigment and synthetic resin on sponges
Paris, Musée National d'Art Moderne,
exhibition installation

46
RE 33, The Gilded Spheres, c. 1960
Les boules dorées
Sponges, pebbles, gold paint and synthetic resin,
74 x 58cm
Paris, Collection M. et Mme Philippe Durand-Ruel

47
RE 26, 1960
Sponges, pebbles and pigment on hardboard,
125 x 100cm
New York, private collection

49
Obelisks: S 33 Blue, S 34 Red, S 35 Gold, 1960
Obélisques, bleue, rose et or
Pigment on obelisks of wood mounted on a stone base,
height 197cm, 195cm, 195cm
Paris, Collection M. et Mme Philippe Durand-Ruel

50
Harry Shunk
Man in Space! The Painter of Space Throws Himself
into the Void!, 1960
Un homme dans l'espace! Le peintre de l'espace
se jette dans le vide!
Photomontage
Private collection

51
Dimanche, Newspaper for a Single Day, 27 Nov. 1960
Dimanche, le journal d'un seul jour
Estate of Yves Klein

52/53
ANT 100, 1960
Blue body imprints on paper, 145 x 298cm
Private collection

54/55
Performance of Anthropométries de l'Epoque Bleue,
Galerie Internationale d'Art Contemporain,
accompanied by Monotone Symphony, 1960
Photographs
Estate of Yves Klein

56 top left
ANT 74, 1960
Body imprints on paper on canvas, 228 x 150cm
Private collection

56 bottom left
ANT 64, 1960
Dynamic body imprint on blue-tinted paper,
207 x 140cm
Private collection

56 bottom right
ANT 13, 1960
Blue body imprint on paper on canvas, 66.5 x 50cm
Munich, Sammlung Lenz Schönberg

57
ANT 73, 1960
Dynamic body imprint on blue-tinted paper
on canvas, 136 x 100cm
Private collection

58 left
Robert Rauschenberg
Female Figure, 1949/50
Monotype on blueprint mounted on handmade
paper, 240 x 91cm
Aachen, Neue Galerie, Sammlung Ludwig

58 top
Henri Matisse
Blue Nude IV, 1952
Nu bleu IV
Cut-and-pasted paper, 103 x 74cm
Nice, Musée Henri Matisse

59
ANT 54, 1960
Body imprint on paper on canvas,
149 x 103.5cm
Private collection

60
ANT 102, Aerial Architecture, 1961
Architecture de l'air
Body imprints and cosmogony with hand-written
text Pigment and synthetic resin on paper on
canvas, 263 x 214cm
Tokyo, National Museum

61
ANT 63, 1961
Pigment and synthetic resin on paper on canvas,
153 x 209cm
Private collection

62
ANT 79, Hiroshima, c. 1961
Hiroshima
Pigment and synthetic resin on paper on canvas,
139.5 x 280cm
Houston (TX), Collection Fondation de Ménil

63
ANT 96, Humans Begin to Fly, 1961
Pigment and synthetic resin on paper on canvas,
246.4 x 397.6cm
Houston (TX), Collection Fondation de Ménil

65
Jacques de la Villeglé
Rue au Maire, décembre 1967
Décollage, 129 x 250cm
Collection of the artist

66
IKB 191, 1962
Pigment and synthetic resin on canvas,
65 x 50cm
Paris, Collection Pierre Restany

67
IKB 191, 1962
Reverse with dedication: "A Pierre Restany au cœur
de la proposition monochrome, Yves le Monochrome
1962"
Pigment and synthetic resin on canvas,
65 x 50cm
Paris, Collection Pierre Restany

68
MG 18, 1961
Gold leaf, pigment and synthetic resin
on cotton on wood, 78.5 x 55.5 cm
Cologne, Museum Ludwig

70
Ex Voto for the Shrine of St. Rita in Cascia, 1961
*Ex-voto offerte par Yves Klein au sanctuaire de Saint
Rita de Cascia*
Pigment and gold in plexiglass
Cascia Convent

71
IKB 75, MG 17, MP 16: Blue-Gold-Pink Trilogy, 1960
Trilogie bleue-or-rose
Pigment, gold and synthetic resin on wood,
each 199 x 153 cm
Humlebæk, Louisiana Museum of Modern Art

72 top
Charles Wilp
Yves Klein with the architect Werner Ruhnau
behind his *Fire Wall*, 1961
Photograph
Berlin, Bildarchiv Preussischer Kulturbesitz

72 bottom
Fire Wall and Fire Sculpture, 1961
Sculpture de feu et *Mur de feu*
Fire performance at Museum Haus Lange, Krefeld

73
F 43, 1961
Traces of fire from the Fire Wall and Fire Fountain,
70 x 100 cm
Private collection

74 top
F 25, 1961
Fire imprint on Swedish cardboard, 200 x 152 cm
Private collection

75 top left
F 36, 1961
Fire imprint on Swedish cardboard, 119 x 79.5 cm
Private collection

75 top right
F 6, 1961
Traces of fire and paint on cardboard on wood,
92 x 73 cm
Private collection

75 bottom left
F 31, 1961
Fire imprint on paper, 61 x 39 cm
Private collection

75 bottom right
F 26, 1962
Traces of fire on cardboard and wood,
73 x 54 cm
Private collection

76 top
Mark Rothko
Number 101, 1961
Oil on canvas, 200.7 x 205.7 cm
Collection Joseph Pulitzer Jr.

76 bottom
Malevich, or Space Seen from a Distance, undated
Malevitch ou l'espace vu de loin
Pencil on paper
Estate of Yves Klein

77
MP 19, 1962
Pigment and synthetic resin on canvas on wood,
92 x 73 cm
Private collection

78 top
Yves Klein/Christo
Wedding Portrait, 1962
*Portrait de Rotraut et Yves Klein le jour
de leur mariage*
Oil on canvas, 213 x 148 cm
Nice, Musée d'Art Moderne et d'Art Contemporain

79
MG 25, 1961
Gold leaf on canvas on plywood, 53.5 x 50.4 cm
Munich, Sammlung Lenz Schönberg

80
RP 3, Here Lies Space, 1960
Ci-gît l'espace
Gold leaf on hardboard with blue sponge
and artificial roses, plywood, 125 x 100 cm
Paris, Musée National d'Art Moderne,
Centre Georges Pompidou

82
Harry Shunk
The Earth Is Blue, c. 1961
La terre est bleue
Photograph
Estate of Yves Klein

83
RP 7, Blue Globe, 1957
Le globe terrestre bleu
Pigment on globe, 19 x 12 cm
Private collection

84
RP 10, 1961
Pigment and synthetic resin on polyester
and fiberglass, 86 x 65 cm
Private collection

85
RP 18, 1961
Plaster on plywood, relief cast of map of France,
58 x 58 cm
Paris, Collection M. et Mme Philippe Durand-Ruel

86
PR 3, Portrait Relief of Claude Pascal, 1962
Pigment on plaster cast mounted on gilt plywood,
175.5 x 94 x 26 cm
Private collection

87
PR 1, Portrait Relief of Arman, 1962
Bronze cast, painted blue, mounted on gilt plywood,
176.5 x 94 x 26 cm
Paris, Musée National d'Art Moderne,
Centre Georges Pompidou

89
Harry Shunk
Yves Klein, 1962
Photograph
Estate of Yves Klein

The publishers wish to thank the museums, archives and photographers for their kind permission to reproduce the illustrations and for their support and encouragement in the preparation of this book. In addition to the collections and institutions named in the captions, the following acknowledgements are also due:

Bildarchiv Preussischer Kulturbesitz, Berlin: 12 top, 32 top left, 33 top right, 72 top:
Christian Leurri: 41;
Musée National d'Art Moderne, Paris: 7, 9 top, 12 bottom, 16, 20 left, 29, 38, 39, 43 bottom, 45 top, 45 bottom, 54 top, 54 bottom, 56 top right, 62, 63, 69, 76 bottom, 80, 83, 84, 87, 90 bottom right;
Musée National d'Art Moderne, Paris, Photo: Harry Shunk: 42 bottom;
Estate of Yves Klein, Rotraut Moquay-Klein and Daniel Moquay, Paradise Valley, AZ: 1, 2, 6, 9 bottom, 10, 13 top, 13 bottom, 17 top, 17 bottom, 18, 19, 20, 21, 22, 24 bottom, 25, 26, 27 top, 30, 31, 32 top right, 32 bottom right, 33 top left, 33 bottom left, 35 left, 35 right, 40, 42 top, 43 top, 44, 46, 47, 49, 52, 56 top left, 56 bottom left, 57, 59, 60, 61, 64 top left, 64 bottom left, 66, 67, 70, 72 bottom, 73, 74 top, 74 bottom, 75 (all), 77, 85, 86, 88, 90 bottom left, 90 bottom middle, 91 top left, 91 top right
Rheinisches Bildarchiv, Cologne: front cover, 36, 68;
Sammlung Lenz Schönberg, Munich: 17 middle, 23, 56 bottom right, 79;
Harry Shunk, New York: 20 right, 24 top, 27 bottom, 37, 50, 51, 55, 64 bottom right, 78 bottom, 81, 82, 89, back cover;
Christine Traber, Berlin: 78 top.